CALNE'S HERITAGE

PETER Q. TRELOAR

The History Press

First published 2010

The History Press
The Mill, Brimscombe Port
Stroud, Gloucestershire, GL5 2QG
www.thehistorypress.co.uk

British Library Cataloguing in Publication Data.
A catalogue record for this book is available from the British Library.

ISBN 978 0 7524 5144 2

Typesetting and origination by The History Press
Printed in Great Britain

CONTENTS

ACKNOWLEDGEMENTS
& BIBLIOGRAPHY

The suggestion for this book came from the publishers to the Calne Heritage Centre and in view of my previous experience in producing books about the town, I was asked to undertake this one. I am grateful to the Heritage Centre for the introduction and for much of the material in the book, some of which originated with the Calne Town Council and the Calne Civic Society. Other illustrations are largely from my own collection. We all owe a debt of gratitude to the photographers who over the years have recorded the history of the town and for the publishers of the picture postcards which form such an important part of the record. My thanks also to Mrs Janet Hopkins for secretarial assistance and my wife for help and encouragement and, in particular, for putting up with our dining room littered with the material for this book for many weeks. Any profit from the sale of the book will go to the Calne Heritage Centre.

I cannot claim to have done original research for this book but have used the following sources, for which I am grateful:

My own previous publications:

Calne in Camera (with R.J. Downham and F.C. Eley) (Calne Borough Council, 1974)
Calne in Pictures (Calne Town Council, 1982)
Calne in Focus (Calne Town Council, 1984)
Greetings from Calne (Calne Town Council, 1988)
Around Calne in Old Photographs (Alan Sutton, 1990)
Calne in Old Picture Postcards (European Library, 1994)
Calne Revisited (Calne Town Council, 1999)

I also wrote a monograph, *Calne Borough Council in the 19th Century*, for the 1973 exhibition marking the end of the Borough Council. For the story of C. & T. Harris I am indebted to the late John Bromham's manuscript *Brief History* of the company. Copies of both of these can be seen in the Heritage Centre.

The Victoria County History of Wiltshire, Volume 17 is invaluable as to the built history of the town.

Other books consulted were:

Marsh, A.E.W., *History of Calne* (Heath, 1903)
Mabbs, A.W., *Guild Stewards Book of Calne (1561-1688)* (Wiltshire Archaeological & Natural History Society, 1953)
Beale, Norman, *Joseph Priestley in Calne* (Author, 2008)
Stedmond, K., *St Mary's School Calne (1873-1986)* (Hathaway Printers, c. 1986)
Maggs, Colin, *The Calne Branch* (Wild Swan Publications, 1990)
Dalby, L.J., *The Wilts & Berks Canal* (Oakwood Press, 1986)
La Vardera, Dee, *Calne: Living Memories* (Frith, 2004)
Rogers, Kenneth, *Wiltshire & Somerset Woollen Mills* (Pasold Research Fund, 1976)

INTRODUCTION

There is no knowing when Calne was first settled by human beings. The prehistoric people who built Oldbury Castle above Cherhill, the Romans who established a town at Sandy Lane (*Verlucio*) and the Anglo-Saxons who built the mysterious Wansdyke across the downs above the town must have been familiar with the area, but it was not until AD 955 that the first written mention of Calne occurred. In that year the Anglo-Saxon King Edred died and in his will he gave Calne and two other towns to the old monastery of Winchester. Calne continued to be an important *Villa Regia* or Royal town during the Anglo-Saxon period and was the occasional meeting place of the *Witenagemot* or Council of the Kingdom. The most famous event in Calne's history took place in AD 978 during a great debate on clerical celibacy. As the *Anglo-Saxon Chronicle* records, 'In this year all the Chief Witan of the English Nation fell at Calne from an Upper Chamber except the Holy Archbishop Dunstan, who alone supported himself on a beam. Some were grievously wounded and some did not escape with life'. This event appears to have settled the argument in favour of clerical celibacy.

Following the Norman Conquest in 1066, Calne adapted to the Norman feudal pattern. The *Domesday Book* (1086) showed the existence of a considerable settlement including seventy burgesses, indicating continuous history as a Borough from Anglo-Saxon times. It probably achieved the shape which it retained until the nineteenth century quite early on, i.e. settlement mostly along the sides of the London–Bath road with burgage plots stretching back from the houses and open fields surrounding the settlement, two of which were commons managed by the town. The map on page 10 shows this pattern still in existence in the eighteenth century and it was not substantially altered until the open fields were enclosed in the early nineteenth century and that century's housing, industrial and transport developments took place. Through those centuries Calne had no remarkable history. It did not even achieve proper status as a Borough as no charter ever seems to have been granted, and what is known about municipal organisation is recorded in the *Guild Stewards' Book*, begun in 1561. It shows that two Guild Stewards elected annually carried on all the very limited administration required in the town. Things were put onto a more regular basis with the establishment of a Borough Council in 1835, which achieved increasing importance in the running of the town until its abolition in 1974 on the establishment of the North Wiltshire District Council.

Calne may have had a castle or perhaps a wooden stockade in Norman times but no evidence of it has been found apart from the existence of the names Castle House and Castle Street, which may indicate that a castle once existed on the site of the former. Calne was not much affected by national events until the Civil War when there was a good deal of fighting in the area, particularly the great battle on Roundway Down in 1643, when a Royalist force sent from Oxford to relieve Devizes heavily defeated a Roundhead army.

As a Borough, Calne was entitled to send two members to Parliament and did so regularly from the thirteenth century until it lost one under the great Reform Act of 1832. The other lasted until the reforms of 1885. Before 1832 Calne was a 'rotten borough'; its few burgesses were easily bought, which is why the reformer William Cobbett wrote:

> From Devizes I came to the vile rotten borough of Calne... I could not come through that villainous hole Calne without cursing corruption at every step; and, when I was coming by an ill looking broken winded place, called the Town Hall I suppose, I poured out a double dose of execration upon it.

Allowance needs to be made for the strength of Cobbett's feelings!

In the economic history of the town there were two overwhelmingly important industries. From the twelfth to the early nineteenth century, Calne played its part in the West Country woollen industry. It was the most important industry in the country, providing a remarkably high proportion of its exports. In the nineteenth century, textile production moved to the more heavily industrialised areas of Yorkshire and Lancashire, so the woollen industry died out in Calne. Luckily, about the same time, the Harris bacon-curing business began to expand. Starting as a small butchers shop at the end of the eighteenth century, it grew into a major industry in the mid-nineteenth century, especially after the introduction of ice to the curing process. At one time the family owned competing industries on opposite sides of Church Street, but they amalgamated as C. & T. Harris (Calne) Ltd in 1888, and thereafter the business expanded, culminating in the huge brick factories towering over New Road and Church Street, built in 1920-32. Unfortunately, the factory became unprofitable in the 1970s and was closed. At its height it had employed 1,700 people whilst employing about 900 on closure. The importance of the industry to the town, which had a population of only 5,000 or 6,000 for most of the period, can hardly be exaggerated. Strangely, virtually all traces of the Harris buildings have been removed whereas there is plenty of evidence of the old woollen industry; as Kenneth Rogers comments, 'Nowhere has the environment of the [woollen] trade in pre-factory days survived better' than on The Green.

With the arrival of the nineteenth century, Calne began a gradual expansion. This was prompted by the arrival of the canal and the railway and the expansion of the Harris factories. New houses were built along London Road, Oxford Road and North Street. Public amenities were enhanced by the provision of gas, water and sewerage services. In the twentieth century expansion to the north of the town began with the first council housing estates in the 1920s. By the time the Borough Council was abolished in 1974, about half of the housing stock in the town was council housing, and new houses, public and private, stretched from west of Lickhill Road to Oxford Road, Abberd Way and Prince Charles Drive. In the post-war period, new schools were provided to replace old ones and educate the growing population, while the industrial estate was established at Porte Marsh Road. Beginning in 1968, major destruction was suffered by the High Street in the construction of the A4 diversion while the Phelps Parade development, in itself destructive (as the photographs in this book show), although intended to replace the lost shops and buildings, has hardly done so.

When no further use could be found for the Harris factory buildings, the whole Harris Estate was bought by the North Wiltshire District Council and a big debate began as to the future development of the town on the Harris land and the High Street frontage. There was great pressure to achieve a holistic development of the town centre rather than piecemeal development. Over a period this has been largely achieved, culminating in the construction of the new library on The Strand and Beach Terrace overlooking the reconfigured River Marden. All that is lacking from the original concept is a connection along The Pippin between Phelps Parade and Church Street. There are proposals for such development but the present economic circumstances are discouraging. An improved new store has just been completed at the end of Phelps Parade; it had been intended for Woolworths but that organisation also became a victim of the recession.

I have again been struck in preparing this book by what Calne has lost over the years. The town was in the past far more self-sufficient. Calne had its own branch canal, railway, Borough Council and Rural District Council, its own water, electricity and gas companies, its own cattle market and its own magistrates. All these things have disappeared and have been replaced, if at all, by centralised, distant organisations. The retail life of the town has also been decimated. I have included in this book a number of advertisements from the Carnival Shopping Week booklet of 1927. There are plenty more in that book which show the extent and vitality of retail activity in the town at the time. The Shopping Week itself showed a great community involvement from the Borough Council, led by the Mayor John Bodinnar (managing director of Harris's) through a committee of many local businessmen to the population who must have participated in the innumerable events during the week. Above all, the week was heavily supported by local tradespeople. Again, centralisation has done its worst and, although Calne has its supermarkets and a limited range of shops, it is no longer possible to buy any goods or services you want in the town in the way it was in 1927. Calne is not unique in this respect; rather it illustrates a national trend.

This is the eighth book of pictures of Calne with which I have been involved. The others are listed in the bibliography. As they were compiled up to thirty-five years ago, it is not surprising that most of them are now out of print, although *Greetings from Calne* and *Calne Revisited* can still be obtained at the Heritage Centre or the Town Council offices. I have had to find nearly 200 illustrations for this book and as it is not easy to find so much new material, I have used a few pictures from those earlier books which are now out of print. This helps to give a full picture. Even so, coverage is inevitably patchy, depending on what is available. I hope that, nonetheless, the book will give a good idea of the history of the town since the invention of photography, with some glances further back.

1

TOWN CENTRE

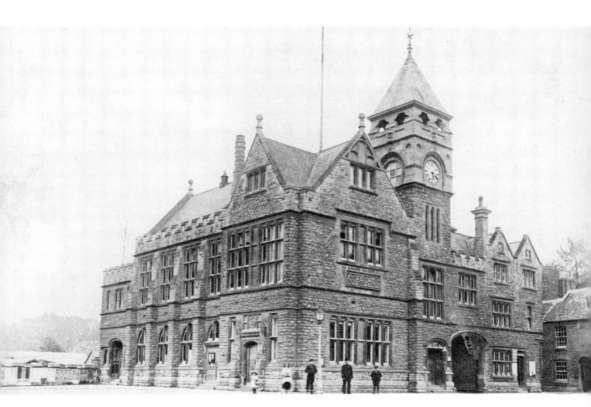

The Town Hall was opened on 27 July 1886, and this postcard published by the Calne printers Heath's shows the building about twenty years later. The stonework is already quite grimy. It has been washed in recent years.

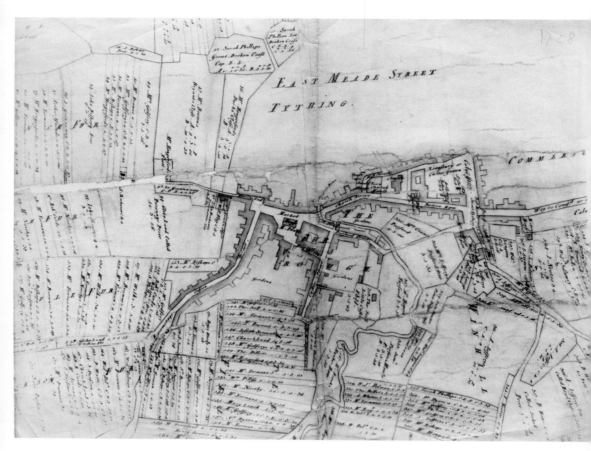

Above: A map of Calne produced in 1728. It shows the town centre as it must have been for centuries before the expansion which occurred in the nineteenth and twentieth centuries. The town effectively consisted of the built-up area along the London–Bath road: Curzon Street, Market Place, Church Street and Rotten Row. There is no Wood Street, only World's End, and no road to Hilmarton. That was created by the Turnpike Trust in the 1790s. New Road was also built at about that time when the canal was being constructed. The only substantial areas off the main road were Mill Street, The Green and Castle Street. The town was closely surrounded by common fields, the ownership of the strips being recorded. Castlefields is at the bottom left and Wenhill at the bottom right.

Opposite above: This fascinating old photograph was brought into the Heritage Centre. It shows the town centre before the building of the Town Hall in the early 1880s. The site of the Town Hall was occupied by the town mill, identifiable by the open door in the gable. In the foreground are the early Harris factories on the south of Church Street and in the background is Castle House. The photograph must have been taken from the tower of St Mary's Church.

Opposite below: A photograph of the town centre looking in the opposite direction from the previous picture and taken at least twenty years later. The Town Hall had opened in 1886. The buildings on the far side of The Strand may be the same as those appearing in the earlier photograph, but the large factory building beyond them is probably new. The roofs of the Lansdowne Arms are in the foreground and the photograph can be dated by the existence of the Technical School on The Green, the building right of centre in the background, which is dated 1894.

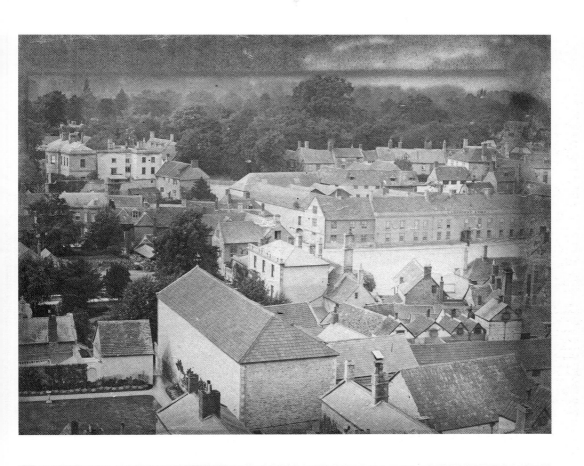

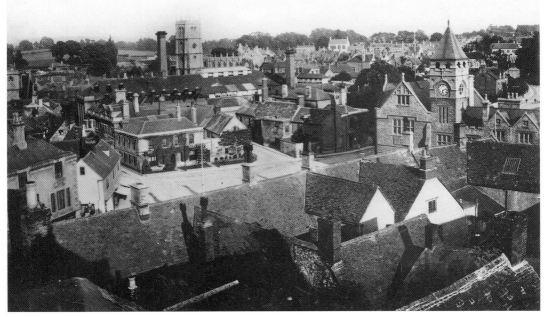

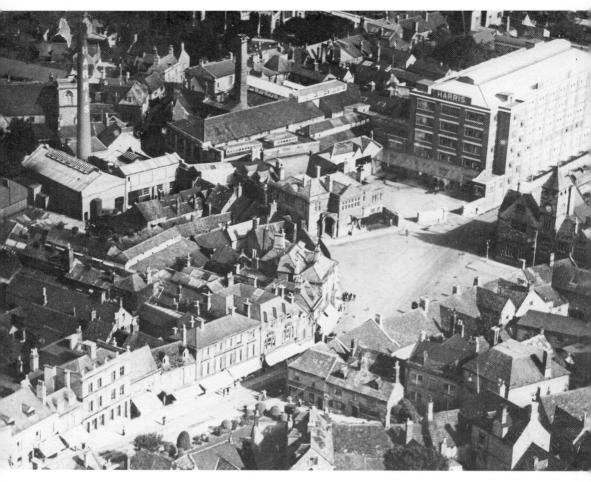

An aerial photograph of the town centre in the late 1920s. The 1920 Harris factory is conspicuous while to its left older buildings still occupy the site of the later 1930s building. The whole of the lower part of the High Street can be seen, almost all of the shops supporting sun blinds, and there are manicured bushes in the town gardens, centre bottom.

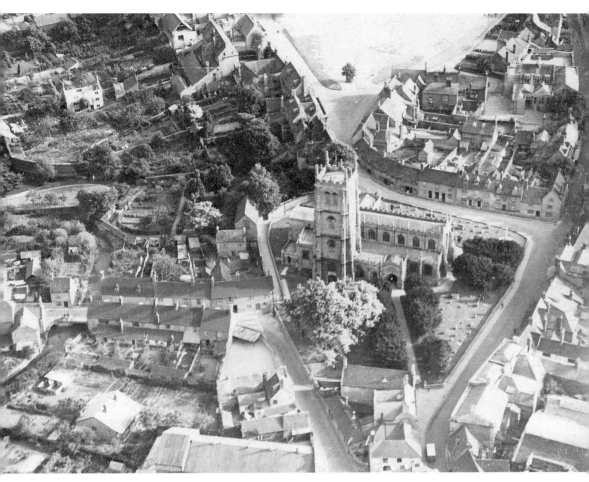

St Mary's Parish Church and the surrounding area, also from the air in the late 1920s. The tin roof at bottom centre covers the Regent Cinema. The mill in Mill Street is on the extreme left and the house and cottage opposite it have since been demolished. There are well-cultivated gardens at the back of The Green but in one of them is the ruin of a house, which has since disappeared completely. The picture can be dated by work going on at the extreme top edge of the picture. No. 10 The Green was once connected to the building at the rear which started its existence as a woollen factory. The connecting wing was demolished in 1929, when the rear part was made into a separate house. The demolition work can be detected in the picture.

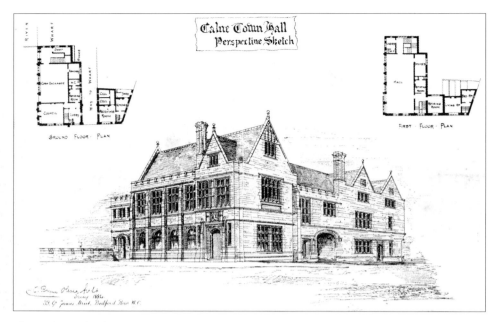

The architect for the new Town Hall was decided by a competition and Bryan Oliver was chosen. It was originally intended to build the new hall in the same location as the old one on Market Hill, but after the old hall had been demolished it was decided that a better site was required and the town mill on The Strand was purchased from Lord Lansdowne for the purpose. Oliver's drawing shows the design as carried out on The Strand site. The only significant change was the addition of the tower which was decided upon during the course of building. The Town Hall cost £9,375, of which £6,515 was given by public subscription.

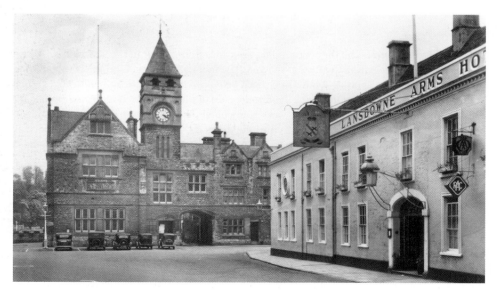

A Valentine's postcard showing the Town Hall and Lansdowne Arms in later years. Judging by the row of cars outside the Town Hall, the picture was taken in the 1930s.

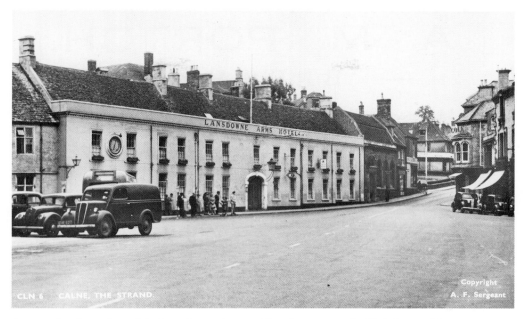

A somewhat later view of the Lansdowne Arms with a glimpse into the High Street. A bus is just pulling up in front of the hotel where a queue of people is waiting to join it. This card was posted in 1953. The large external barometer, which is still a feature of the hotel, is visible above the van.

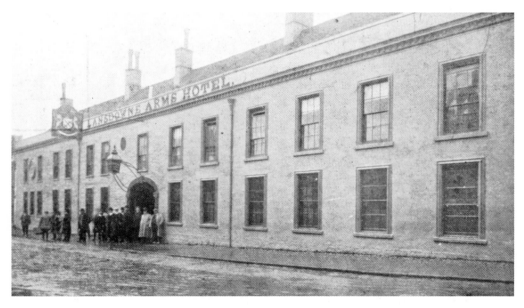

An early advertising postcard of the Lansdowne Arms Hotel. This was produced by C.E. Fox & Co., brewers, wine & spirit merchants. For many years there was brewery in the yard at the rear of the hotel. The hotel has had a complicated architectural history and probably assumed its present appearance towards The Strand in the mid-nineteenth century. The central archway which is now the entrance and reception was still used as an access to the rear yard at the time of the photograph.

A. M. PORTCH,

— BREWER, —

Wine and Spirit Merchant,

CALNE.

WINES AND SPIRITS

all best brands kept.

Single bottles at per dozen rate.

BEERS brewed on the premises

from Finest English Malt & Hops **only,**
supplied in small casks and jars.

Agent for Devon and Somerset Ciders.

Send for Price List. **Telephone 47.**

The Lansdowne Arms Hotel,

— CALNE, —

23 BEDROOMS. ELECTRIC LIGHT. GARAGE.

LUNCHEONS. TEAS. DINNERS.

"Everything of the best."

A. M. PORTCH, Proprietor.

An advertisement for the Lansdowne Arms Hotel which appeared in the *Carnival Shopping Week* booklet for 1927. The proprietor has changed from Fox to Portch but the brewery is still mentioned.

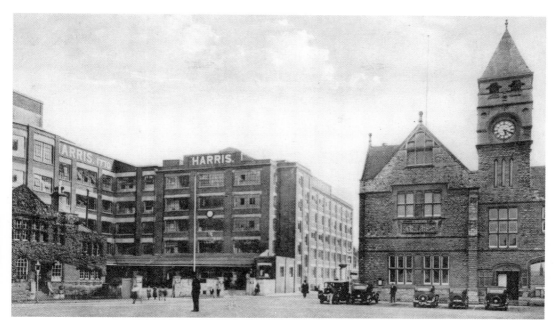

A postcard view of The Strand which takes in the Town Hall and the Harris factories. This also seems to date from the late 1930s – indeed the cars look the same as those in the earlier picture. The right-hand wing of the Harris factory was built in 1920 and the left-hand wing in the early 1930s.

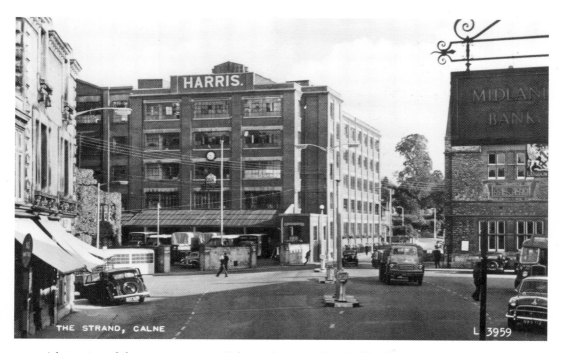

A later view of the same scene on a Valentine's postcard, probably taken in the 1950s. There is more traffic to be seen and street furniture has begun to appear in the middle of The Strand.

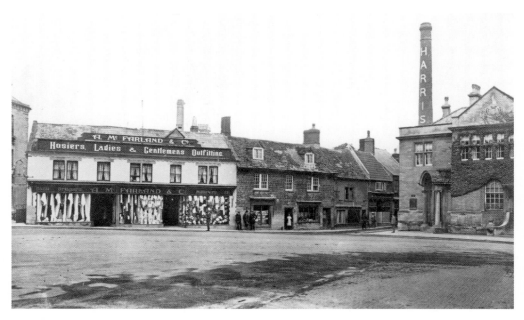

Looking across The Strand towards Church Street on a postcard which was posted in 1920. The row of shops in Church Street is still intact and McFarland's shop has a fine window display.

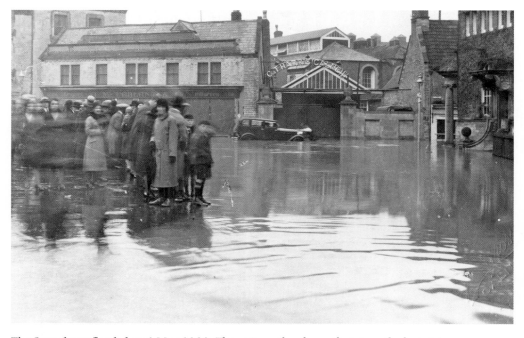

The Strand was flooded on 1 May 1932. The picture also shows that since the last picture was taken, Harris's had demolished the house next to McFarland's and created a new entrance to their factory which can be seen behind. It looks as if McFarland's has shut. The signs are faded and the blinds are down. Perhaps the Great Depression had struck.

A. McFARLAND & Co.

THANK THEIR FRIENDS
FOR THE GENEROUS SUPPORT
OF THE PAST YEAR.

They wish to announce that they are
now making their own

MEN'S SHIRTS, PYJAMAS
— AND —
LADIES' UNDERCLOTHING.

These Garments are fully cut,
only the best quality materials being used,
and will outwear any small cut factory
article.

Watch the Window Displays
during Shopping Week.

THE STRAND, CALNE.
Also at CARSHALTON.

McFarland & Co. were still flourishing in 1927 as their advertisement in the Carnival Shopping Week booklet shows. It is interesting that they also had a shop in Carshalton.

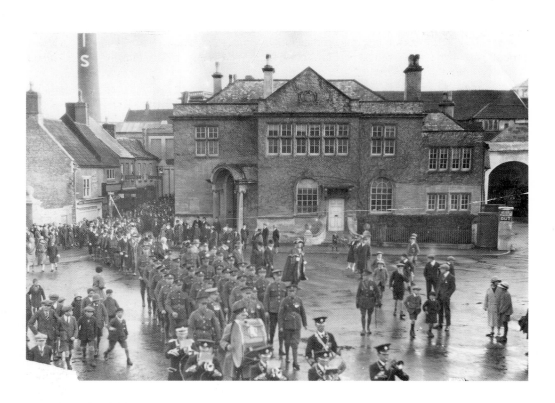

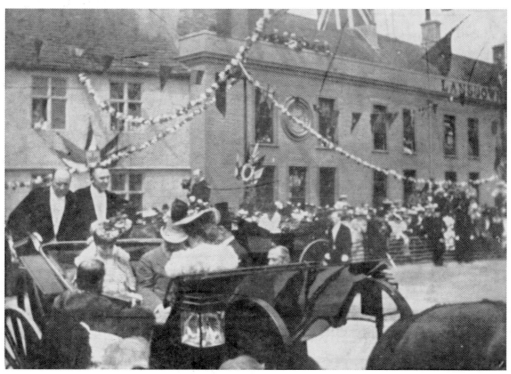

Opposite above: The Remembrance Day parade in 1926 comes down Church Street and across The Strand. The Town Council can be seen behind the band and the military detachment. Church Street is crowded with the rest of the procession.

Opposite below: A great event in the life of the town was the visit by King Edward VII and Queen Alexandra on 22 July 1907. The Royal couple had been staying at Bowood and drove through the town en route to the station. They stopped at the Town Hall to receive a loyal address from the Mayor. This postcard by Heath shows the moment at which the Mayor presented the loyal address to the King and Queen.

Preparations for the Royal visit were made by a large committee headed by the Mayor, J.E. Wood. They raised money to pay for the arrangements and produced a booklet, of which this is the cover.

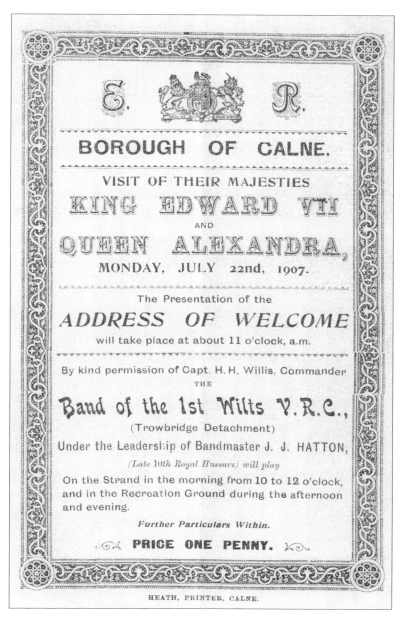

E. R.

BOROUGH OF CALNE.

VISIT OF THEIR MAJESTIES

KING EDWARD VII

AND

QUEEN ALEXANDRA,

MONDAY, JULY 22nd, 1907.

The Presentation of the

ADDRESS OF WELCOME

will take place at about 11 o'clock, a.m.

By kind permission of Capt. H. H. Willis, Commander

THE

Band of the 1st Wilts V.R.C.,

(Trowbridge Detachment)

Under the Leadership of Bandmaster J. J. HATTON,

(Late 10th Royal Hussars) will play

On the Strand in the morning from 10 to 12 o'clock, and in the Recreation Ground during the afternoon and evening.

Further Particulars Within.

PRICE ONE PENNY.

HEATH, PRINTER, CALNE.

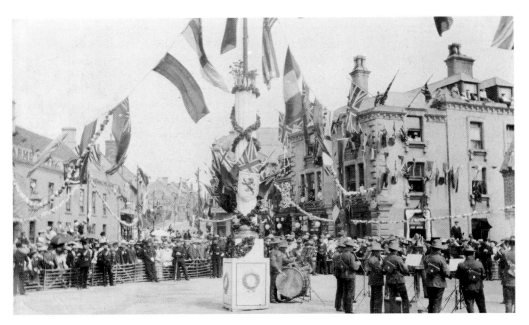

Despite the brevity of the Royal visit, the town put huge effort into preparing for it. The extent of the decorations can be seen in this picture looking across The Strand and up the High Street. Hurdles had been erected to keep back the crowds from the area where the Royal coach would enter The Strand from Church Street and turn in front of the Town Hall.

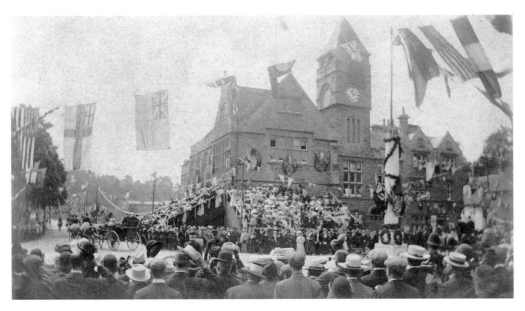

The presentation to the King and Queen is over and the Royal carriage moves away from the Town Hall towards the station. That was the end of the event for the crowds in the street and on the grandstands erected outside the Town Hall. However, there were sports in the Recreation Ground all the afternoon, from conventional running to a donkey race and the greasy pole.

2

THE HIGH STREET AND THE SQUARE

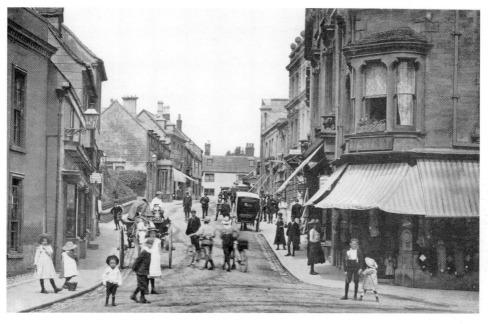

A superb study of the High Street in Edwardian times by the Calne photographer Harold R. Gross. Everyone in the picture except the two cyclists in the centre seems to have been persuaded to pose. The central gardens can be seen on the left and the buildings in The Square at the top of the High Street are clear. What is now Lloyds Bank had been doubled in width sufficiently recently for the new stonework to show up. The buildings on the right disappeared during the road widening of 1968. The shop at the right bears the name Hewett, but for most of the twentieth century it was Cole the drapers.

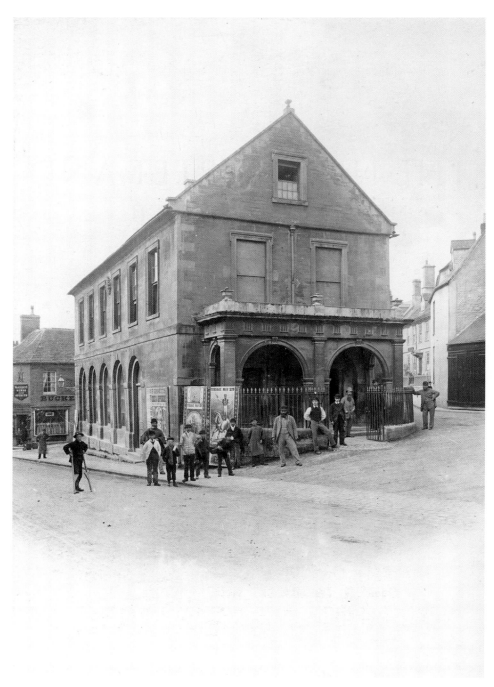

The Old Market Hall in the High Street. The upper floor was used for Borough Council meetings. As previously explained, the feeling arose that it was inadequate and in 1882 fundraising began for a new Town Hall. This one was demolished in 1883 with the intention of building a new one on its site, but in the event it was thought preferable to build the new hall on the site of the old town mill on The Strand. The site of the old hall was left open and became the central gardens.

BUCKERIDGE

FOR

GROCERY,

AND

Everything in the DRINK LINE.

AGENT FOR

BASS, GUINNESS, WORTHINGTON, ROGERS, WHITBREAD, SIMMONDS,

BEER & STOUT,

in Cask, Flagon and Bottle.

- - Barclay's Lager. - -

Speciality—

WORTHINGTON'S BURTON DINNER ALE

in pints 7/- doz. Quarts 1/- each.

AGENT FOR

W. & A. GILBEY'S WINES AND SPIRITS
Buchanan's BLACK & WHITE.

∴ KEYSTONE SPECIALITIES. ∴

Good, Pleasant-drinking WINES from 2/6 bot.

ÆRATED WATER in pint screw-top bottles.
Also Agent for SCHWEPPES ÆRATED WATERS

CIDER IN CASK AND BOTTLE.

BUCKERIDGE, HIGH STREET & CALNE. MARKET HILL.

Generations of pictures taken looking down the High Street show Buckeridge's shop on the corner of Market Hill, as can be glimpsed behind the hall in the last picture. Although latterly known as an off licence (as it is today under different ownership), it was originally also a grocery. This advertisement also appeared in the 1927 Carnival Shopping Week booklet.

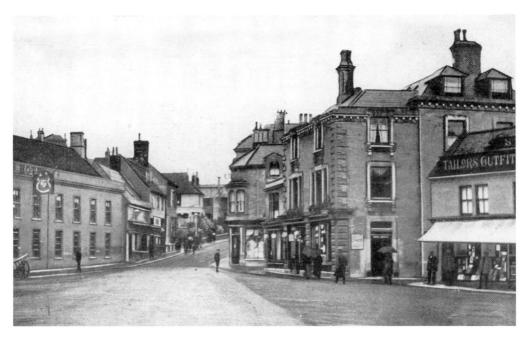

An early postcard of the junction of The Strand and High Street. The buildings which lasted until 1968, are on the right, and to the left of the High Street can be seen the central gardens and the projecting building which housed Henly's grocery stores.

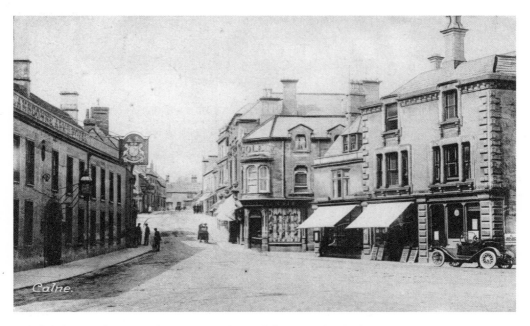

A slightly later card showing the same scene from a different angle, which permits a view right through to the buildings in The Square at the top of the High Street. Judging by the car, this appears to be the 1920s. The name Cole can be seen above the bay window in the prominent shop in both pictures.

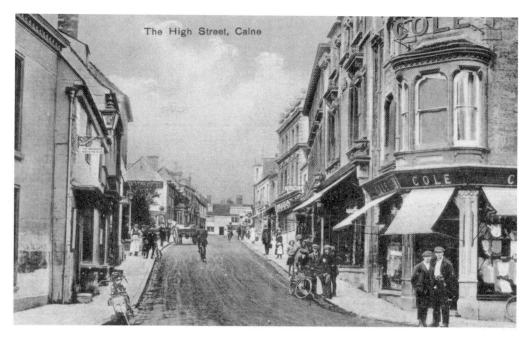

A closer view of the High Street on a picture postcard. The motorbike on the left and the caps worn by the men again suggest a date in the 1920s. The muddy state of the High Street is rather surprising for such a date but that may simply be evidence of the continued large-scale use of horse haulage.

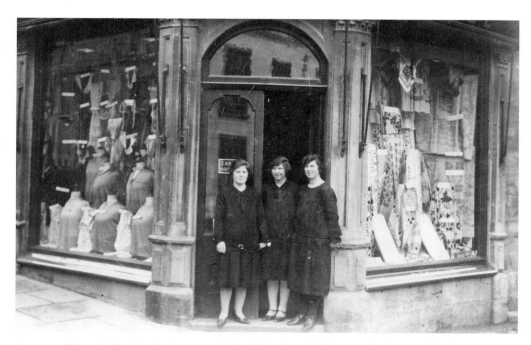

A group of three lady attendants pose outside Cole's shop. Unfortunately, their names and the date (perhaps between the wars) are not recorded. The windows give some idea of the goods on sale.

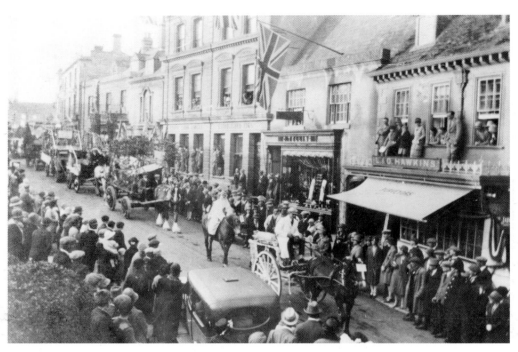

A procession comes down the High Street in Carnival Shopping Week, 1925. L. & O. Hawkins on the right were long-established butchers and next to them was Telling the saddler.

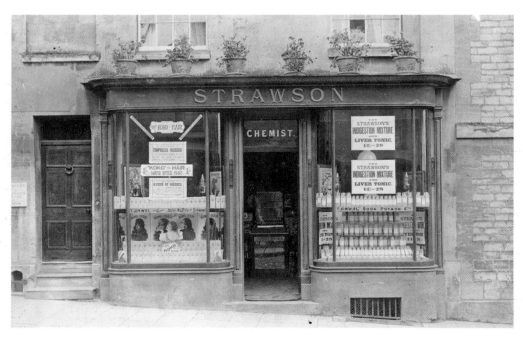

Strawsons was a chemist in the building on the High Street which in later years became Jeary's pharmacy and is empty at the time of writing.

C. TELLING,

High Street, Calne,

Saddle and Harness Maker.

SPORTS OUTFITTERS.

Footballs, Golf, Hockey, Tennis, Cricket, Bowls, &c.

Overland and Cabin Trunks, Dress Baskets,
Week-end and Attache Cases,
School Bags, Music Cases, &c.

Leggings, Collars, Belts, Braces, Gloves, Gaiters.

WALKING STICKS AND WHIPS.

Fancy Leather Goods, Purses, Pocket Books,
Wristlet Watch Guards, Bags, Wallets, &c.

SPONGES, CHAMOIS, BOOT POLISHES, HARNESS,
MACHINE AND PURE LINSEED OILS.

BRUSHES AND STABLE REQUISITES ALWAYS IN STOCK.

Every Description of Ropes and Twines,

Agent for Belfast Binder Twine.

All Repairs promptly executed at moderate charges.

ANIMALS AND BIRDS STUFFED AND MOUNTED.

Telling's advertisement in the 1927 Calne Carnival Week booklet. Although the shop is usually described as a saddlers, it can be seen that it sold a wide range of other items including sports equipment. The shop is now Centre News, and during a recent redecoration the name Telling was exposed on an old fascia board.

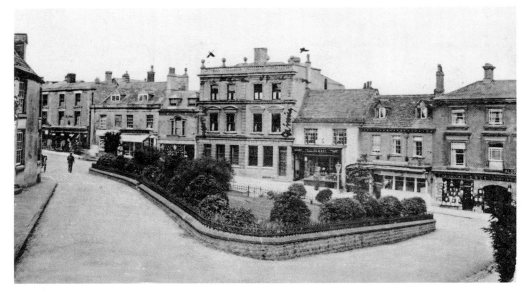

The origin of the central gardens has already been recounted in relation to the old Town Hall. The little wall was surmounted by purpose-made iron railings manufactured by Maundrell's Foundry of Calne. The card was posted in 1926 but the photograph was probably taken considerably earlier. The sender comments that she lives in the bank building but that, 'there are no Venetian blinds now'. The central gardens were swept away in the 1968 road widening, and the building on the right and those below it were also demolished.

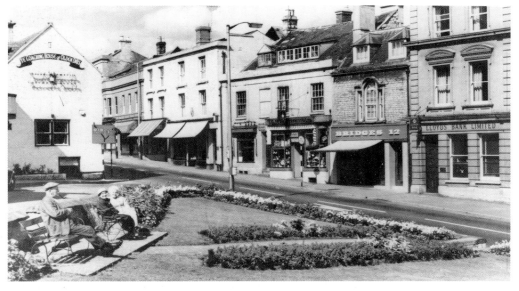

A view of the central gardens after the Second World War. The buildings shown have survived although the chemists in the centre looks more as it did in Strawsons' day than it does now. There is a road sign adjoining the end of the King's Arms indicating the junction of the A4 and A3102 in The Square.

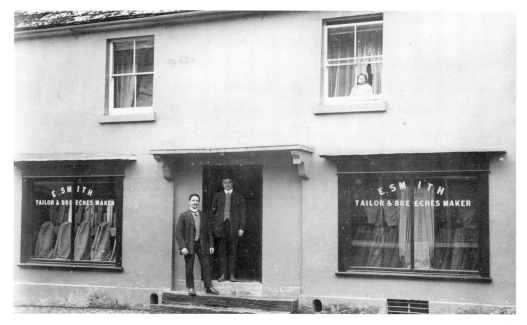

This postcard of the premises of E. Smith, tailor and breeches maker, was posted in 1909. The building was No. 24 High Street which was just above the King's Arms, and was demolished to make way for the new Post Office in 1953.

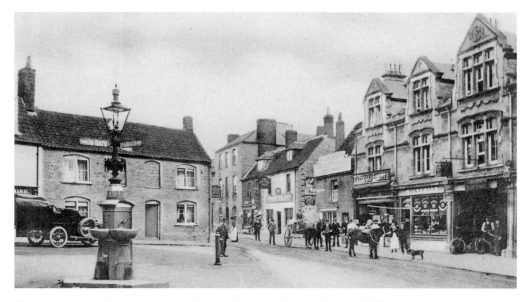

The space created by the junction of the High Street, Curzon Street and Wood Street was known as The Square. The motor car in this postcard places the picture early in the twentieth century. In the centre is the White Horse Inn. Next to it on the right, the large sign proclaimed 'W G Dobson Printer Stationer Bookbinder'. Next along is Eastman's butchers, then a branch of Wiltshire's Grocery and doors leading into Wilkins Ironmongers, who had a shop frontage further down the High Street.

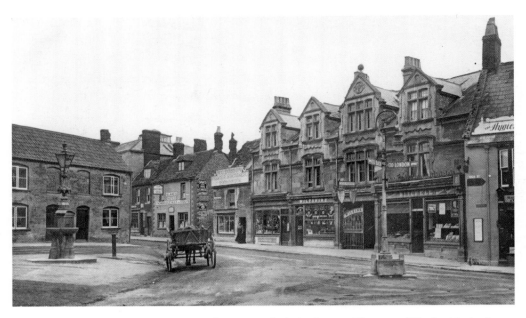

This is probably a slightly later photographic postcard of The Square. The central block with the four big dormers was called Phelps Chambers and later gave its name to Phelps Parade. The right-hand shop in the block is signed Mitchell but it is difficult to see what is being sold. All the buildings on the right of the White Horse were demolished to make way for the building of Phelps Parade in 1973.

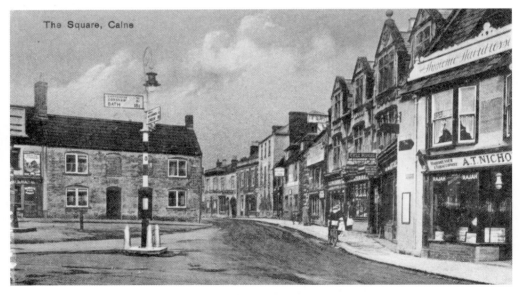

The Square, Calne

Another postcard of The Square and Wood Street, probably from the early 1920s. The main change from the earlier views seems to be a more modern type of signpost. The range of two-storey buildings facing down the High Street was demolished in 1934 and was replaced by the modernistic Calne Co-operative Society building, which still survives, although not for the same use. The new building curved round into Wood Street and so effectively did away with The Square.

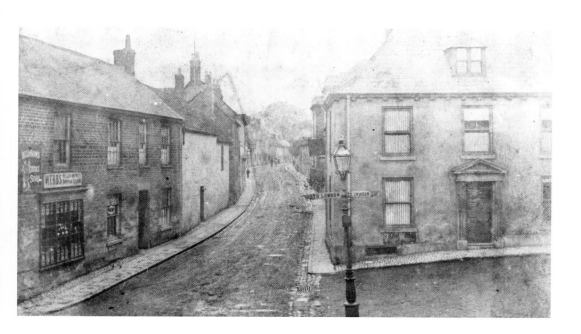

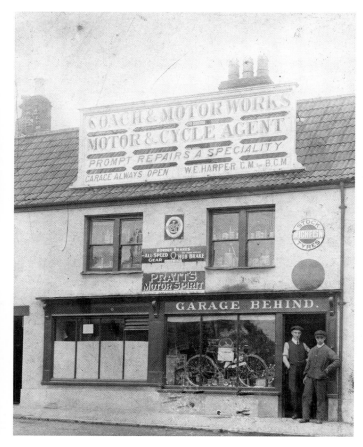

Above: Looking along Curzon Street from The Square, *c.* 1890. Webb's Grocery and the adjoining white building were demolished to make way for the new Post Office building of 1953. The building on the right was demolished when the Co-op building was further extended in that direction.

Left: Further along The Square was a coach and motor works which had its vehicular access from Wood Street (thus 'garage behind'). The photograph shows it was owned by W.E. Harper. The sign on the roof reads, 'Coach and Motor Works, Motor and Cycle Agent, Prompt Repairs a Speciality, Garage Always Open'. The enamel advertisements on the frontage include Bowden Brakes, Pratt's Motor Spirit and Michelin Tyres.

MOREMENT & BRIDGES,

ALL REPAIRS EXECUTED IN ACCORDANCE WITH THE GUARANTEED REPAIRERS' SCHEME OF THE INSTITUTE OF THE MOTOR TRADE

Motor & Electrical Engineers,

THE SQUARE, CALNE, WILTS.

We are Specialists in all Branches of the Motor Trade, including Bodymaking and Painting.

We can supply any make of Car or Motor Cycle, or we can build you a Car for any special requirements.

Call and have your tyres inflated free of charge by special machinery.

Repairs to		Wireless
Wireless		Batteries
Sets.		charged.

REGISTERED ELECTRICAL INSTALLATION CONTRACTORS

ELECTRIC LIGHTING AND POWER INSTALLATIONS.

TELEPHONE 59.

Harper's business later passed to Morement & Bridges and this is their advertisement from the 1927 Carnival Shopping Week booklet. Their business has extended beyond motor vehicles to electrical engineering, including repairs to wirelesses and electric installations.

3

CHURCH STREET
AND MILL STREET

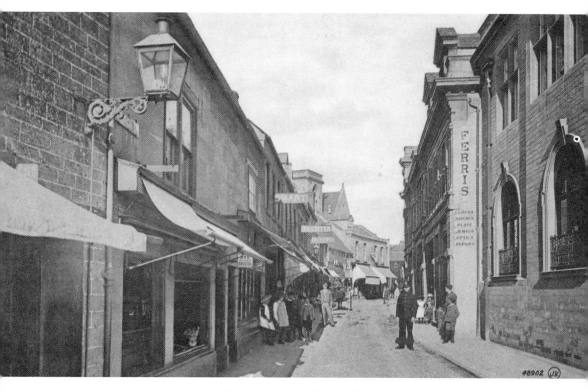

An early twentieth-century view of the lower end of Church Street before any of it had been demolished to allow for expansion of the Harris factories. Notice the policeman standing in the road. Ferris's shop on the right was a jewellers.

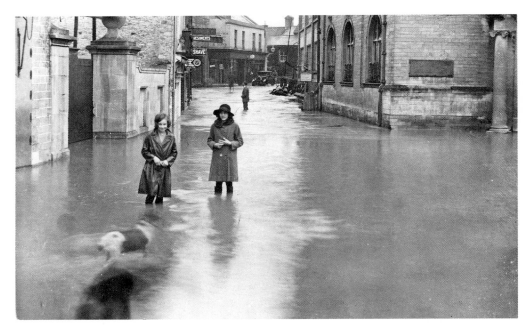

Flooding of Church Street and The Strand was quite common because of constriction of the River
Marden by the close proximity of the Harris factories. This flood occurred in 1934, by which time
the Harris's entrance had been opened on the left and the 1932 wing of the factory had appeared in
the centre in place of Ferris's shop. The projecting signs on the left say 'Refreshments' and 'Shave'.

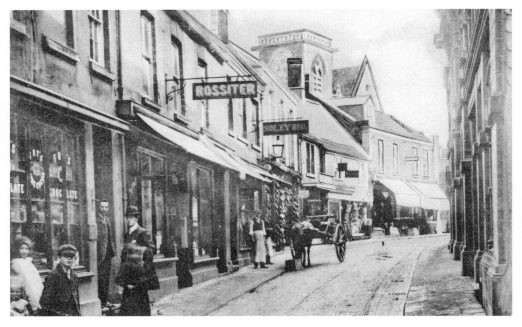

A much earlier view of the shops in Church Street on a postcard sent in 1906. Dixon's drapery store
is in the distance with the Free Church behind it.

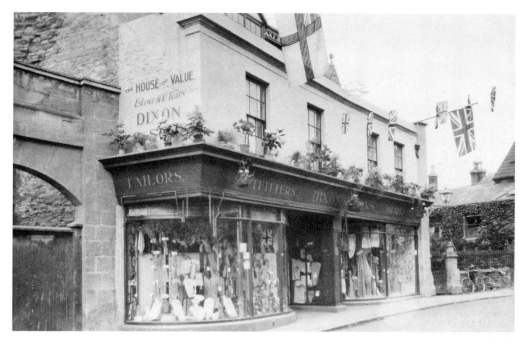

Dixon's premises at No. 20 Church Street decorated for a celebration in the 1930s, possibly the Silver Jubilee in 1935. Dixon's business was established before the end of the nineteenth century and continued until the 1990s. Part of the premises of Wiltshire's the grocers can be seen beyond the wall of the Free Church frontage on the right.

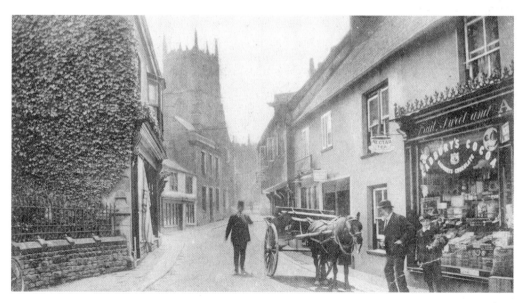

Another early postcard, this one posted in 1909, showing Church Street a little further up. Wiltshire's store is on the left. The buildings on the right were absorbed into the factory area and were demolished and replaced by the buildings which appear in subsequent scenes.

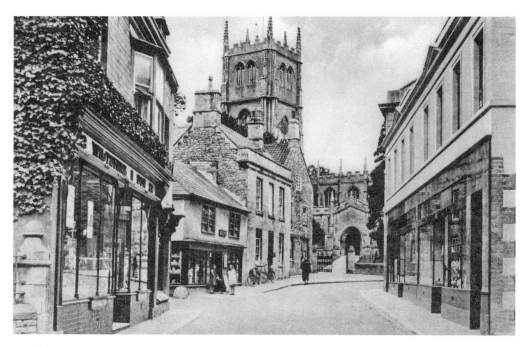

Roughly the same view at a later date when the buildings on the right had been replaced by the new Georgian-style block, which still exists. The entrance to Mill Street beyond Wiltshire's premises is only just apparent.

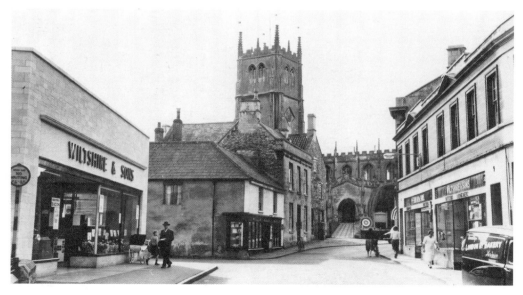

Wiltshire's were pioneers in the introduction of supermarkets. They replaced their old building with this modern one in the 1960s. It did not last long, soon being replaced by the much larger supermarket premises that still exist fronting onto Mill Street. The shops on the right contained Wiltshire's butchery department.

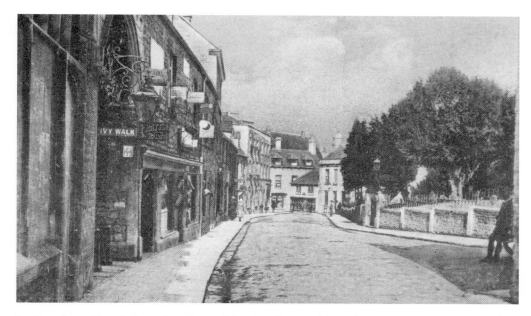

Looking down Church Street from beyond the church, probably in the 1920s. Wiltshire's building is prominent in the centre. The buildings on the left side of the street remain much the same today and the churchyard can be seen surrounded by low iron railings, which were removed for the scrap effort during the war.

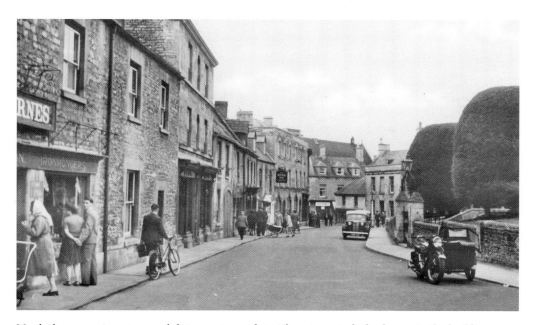

Much the same view at a much later, post-war date. There is again little change in the buildings. Barnes' shop on the left was a very long-established ironmongers which retained its character until closure, probably in the 1990s. The railings have disappeared from the churchyard and the yew trees have been manicured.

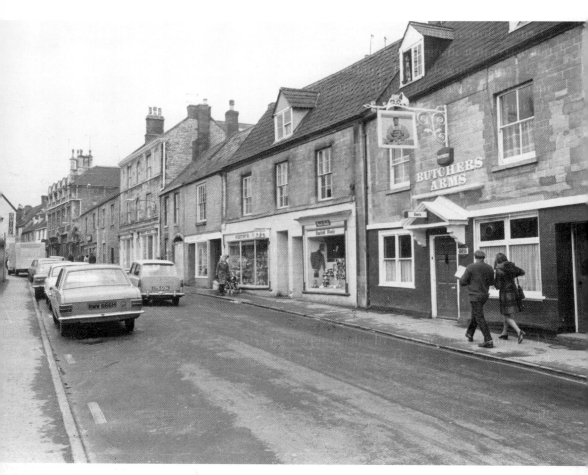

A view of the buildings facing the churchyard in Church Street. It is undated but is possibly from the 1970s. The ones this side of the three-storey building were acquired by the District Council along with the Harris factory sites. They were subsequently renovated and restored under the auspices of the Wiltshire Historic Buildings Trust in the 1980s. The Butchers Arms closed as a pub and is now in private ownership.

Opposite above: The same part of the street looking in the opposite direction on a postcard posted in 1973. Since the picture on page 39 was taken, Wiltshire's first supermarket has come and gone. Its site can be made out in front of the Free Church. Work seems to be going on which must have been to create the new supermarket and widened entrance to Mill Street. The three-storey block on the right had been connected to the Harris factories and required very substantial renovation in the 1980s scheme. The poet Samuel Taylor Coleridge is believed to have lived in one of these houses between 1814 and 1816.

Opposite below: The upper part of Church Street in an early twentieth-century card. One of the chimneys of Harris's factory is in the centre and the rear of what was then the Grammar School is on the right. The buildings seen are largely unchanged to this day.

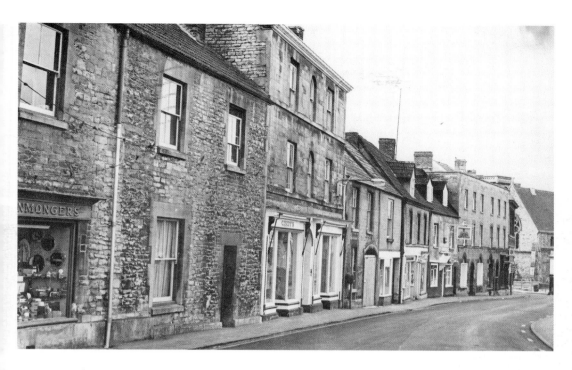

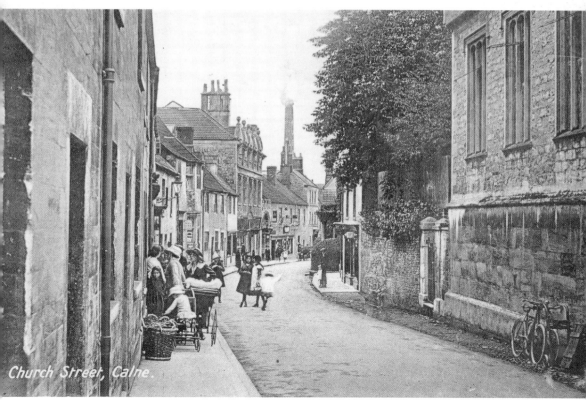

Church Street, Calne.

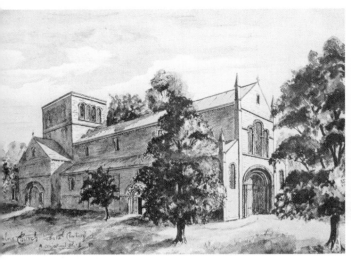

St Mary's Church began as a Norman structure with a central tower, as shown in this 'conjectural sketch' on a Heath postcard. During the following three centuries additions were made which changed it outwardly into a Gothic building. The fall of the tower on 26 September 1638 was followed by the erection of the present tower at the northern end of the transept and the restoration of the chancel in the Renaissance style. On the card is written, 'So complete a succession of styles from Romanesque to Renaissance in one building is very rare and makes the Church one of quite exceptional interest'.

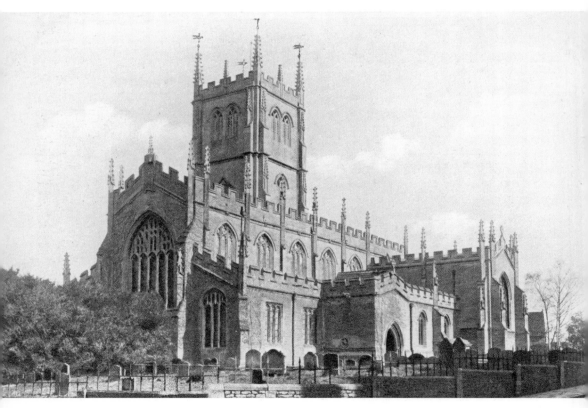

An early postcard of the church, also published by Heath. It shows the homogenous appearance achieved during the Victorian reconstruction. All that remains of the Norman building referred to above are the arcades in the nave and fragments of the outer walls of the aisles. The picture was taken before the erection of the 1918 War Memorial and while the churchyard was still surrounded by miniature iron railings. The vanes on the pinnacles of the tower were a notable feature, later removed for safety reasons.

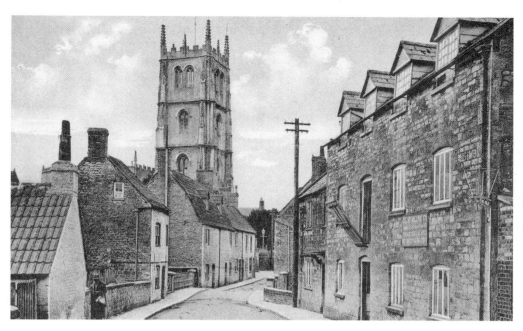

An early postcard of Mill Street. The mill on the right, bearing the signboard 'Calne Milling Co.', is in working order. The narrow-fronted cottage and outbuilding on the left have since been demolished.

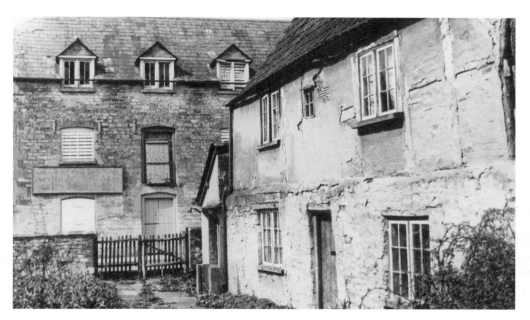

There was an interesting house or cottage opposite the mill. As this picture, probably taken around 1970 in its final days, shows, the upper storey was of wooden-frame construction and the very steep pitch of the roof suggests it may have originally been thatched. The mill beyond is boarded up and has since been converted into a residence. A modern house, which temporarily served as the vicarage, now stands on the site of the cottage.

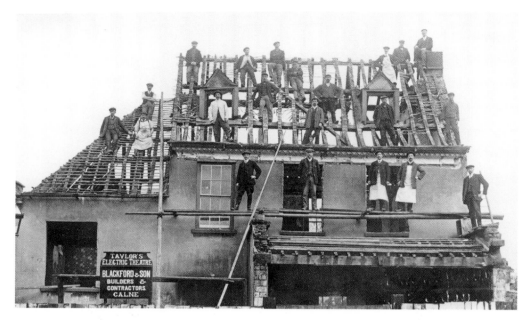

Another rather attractive building in Mill Street which was demolished. Blackford's men are at work taking down the building to make way for 'Taylor's Electric Theatre'; in other words the cinema. Earlier photographs show this as the flourishing and well-maintained shop of 'Walter Hill, Painter and Plumber'.

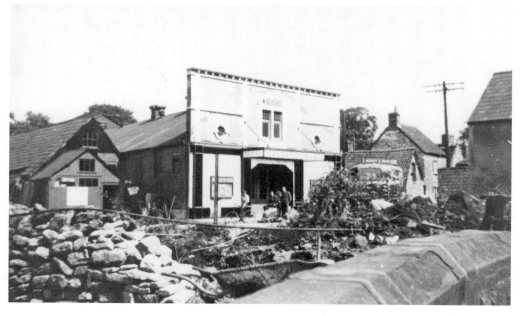

The Regent Cinema in its later days. It can be seen that the fairly impressive façade to Mill Street hid nothing more than a tin-roofed shed. All the buildings shown except the one on the extreme right were swept away to make room for the big new supermarket and car park in the early 1970s. The wall in the foreground marks the front of the Free Church premises.

4

NEW ROAD TO QUEMERFORD

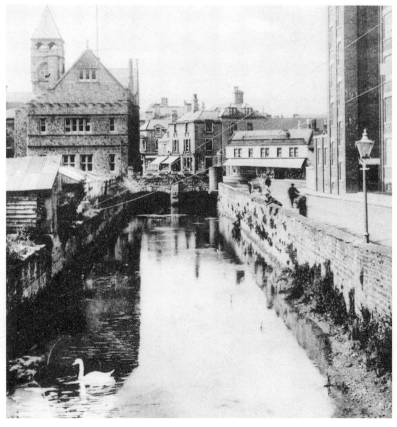

Looking up the Marden alongside New Road with the Town Hall, The Strand and Harris's 1920 factory. The Wharf on the left is covered with ramshackle buildings. The Calne branch of the Wilts & Berks Canal had opened in 1802 when this section of the river was canalised to create the Wharf and New Road was constructed. The canal had fallen out of use by 1900.

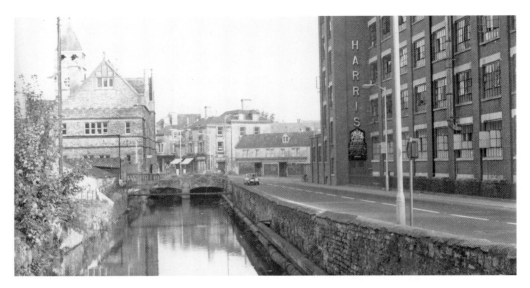

Towards the end of the Harris era very little had changed from the previous view. By this time Harris's were using the Wharf as a car park and their name, with the arms of the Royal Appointment, had appeared on the 1920 factory. The gas lamp by the river had also been replaced with something less attractive.

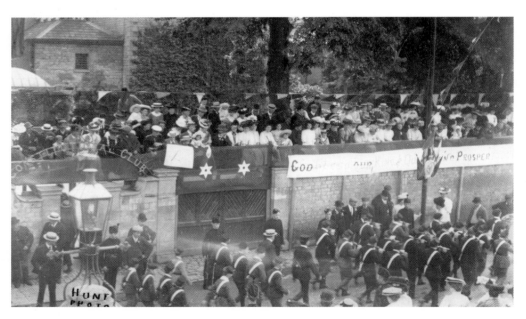

I was very intrigued to find this postcard taken by Hunt of Calne. There is nothing to indicate the occasion or location. However, I am pretty sure that it shows the crowds in Harris's premises facing New Road on the occasion of the visit of King Edward VII and Queen Alexandra in 1907. The long banner reads, 'God Bless our King and Queen and Prosper Them'. A group of soldiers is marching along the road. The curved sign on the left says 'Constitutional Club' and I have found an indication that Harris's promoted such a club, which was presumably later moved to the premises built where Ivy Walk meets Church Street, the one-time Conservative Club and recently a Chinese restaurant.

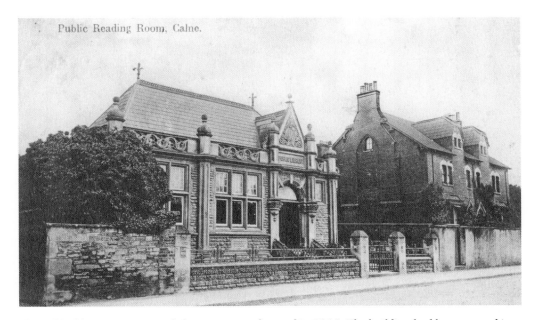

Public Reading Room, Calne.

The public library in New Road shown on a card posted in 1918. The building had been opened in 1904 and bears the inscriptions, 'This building is the gift of Andrew Carnegie' and 'This stone was laid July 16 1904 by the Earl of Kerry'. There is a gable bearing Calne's armorial bearings above the doorway. In later years the library became the responsibility of the Wiltshire County Council and was closed when the new library was built on The Strand.

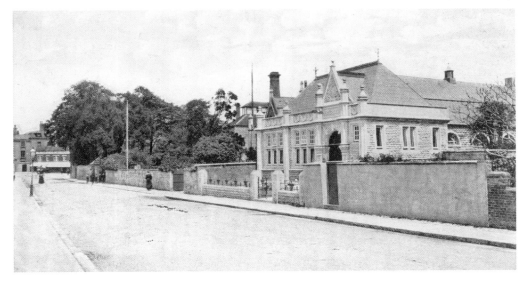

A view of the library looking in the opposite direction, this time on a Valentine's postcard sent in 1908. It must have been very new when this picture was taken. Beyond, the trees hide most of the then-modest Harris's buildings. The crowd watching the Royal visit shown on page 46 was in front of the trees. The old library has now become the Calne Heritage Centre which was declared open by the present Earl of Kerry on 5 October 2004.

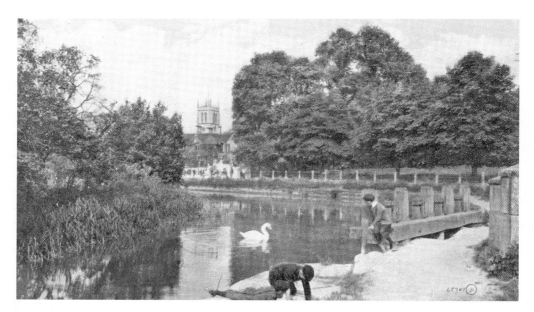

The hatches were at the point where the canal joined the river. The canal, having come up the valley from Stanley, had a final lock just behind Marden House which raised it to the level of the river which, in turn, was maintained at the height required for navigation. This was done by the hatches, which allowed water not required for the canal to flow into the original river channel. The river now runs at a much lower level than it did when maintained at the height required for the canal. It flows under the bridge which once supported the hatches, which have entirely disappeared.

A view looking towards the town centre from the station. Marden House is prominent in the centre. Two Harris factory chimneys can be glimpsed through the trees and the tower of St Mary's Church can just be seen behind Kerry Crescent. The gates of the top lock of the canal can clearly be made out behind the fencing on the right. Marden House served as the wharfinger's base when the canal was operating. It eventually became part of the Harris premises, used as a store for old papers. The District Council, having acquired it with the rest of the Harris property, made it available to a local group who converted it into the community hall it is now.

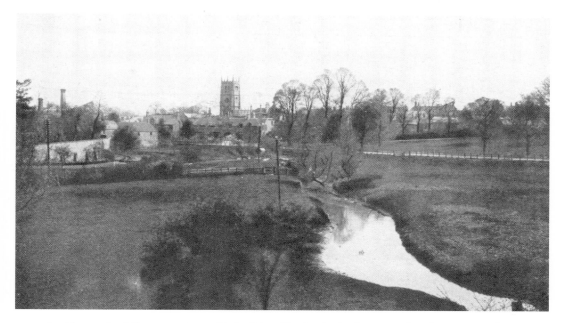

A wider angle of the same view with the River Marden in the foreground and Station Road on the right. The grounds of the Woodlands are very open, giving a view right across to The Green. The house known as The Woodlands itself was built around 1870 and must be off to the right of the picture. In the centre the tall elm trees are a reminder of a very important feature of the Wiltshire countryside which was wiped out by Dutch elm disease in the 1970s.

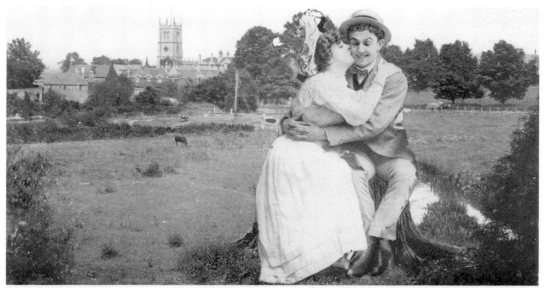

Calne I am quite fascinated by the "surroundings" here

The same view with an overprinted comic/romantic scene. A lot of these cards were published with various Calne scenes in the background. This one was posted in 1911.

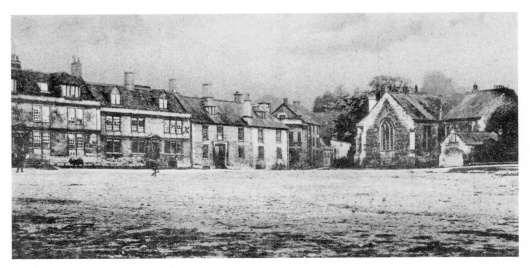

This corner of The Green has changed little since this postcard was published, probably in the 1920s. It can be seen that The Green was gravel rather than grass at the time and behind the White Hart can be glimpsed the house known as South Place on the corner of London Road and Silver Street. The Boys' National School of 1829 on the right has since been converted into two residences.

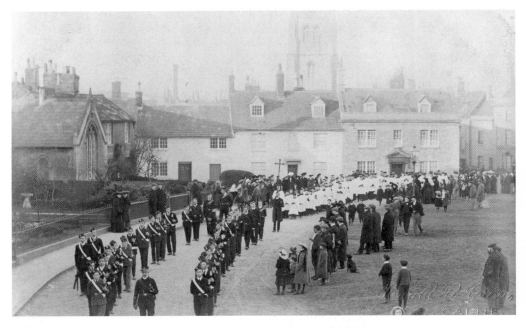

Canon Duncan's funeral procession crossing The Green, 2 February 1907. He had been Vicar of Calne since 1865 and had been extremely active in church and local work. He was a founder of St Mary's School, which was first located in the buildings behind the procession. The procession marched from St Mary's to Holy Trinity churchyard and included the Bishop of Salisbury and the Mayor and Corporation, while Lord Lansdowne was among the pallbearers. The buildings in the picture remain much the same today. The one on the left, the Girls' National School, has also been converted to residential use.

The building known as Nos 8 & 9 The Green has had an interesting history. It may have been built as a silk factory in around 1828. At some point it became used as an orphanage and for a while it even became known as 'The Orphanage', but during the First World War it seems to have been used to billet soldiers and subsequently as a hostel for girls working in the Harris factories. Later it was used for a while by the girls' section of the secondary school when it opened on The Green. The picture must relate to the military occupation during the First World War. It was posted in 1915. The writer, Jack, says, 'This is where we are staying'. The railings went for scrap in the Second World War and the veranda has been removed but otherwise the building remains much the same and it is now in residential use.

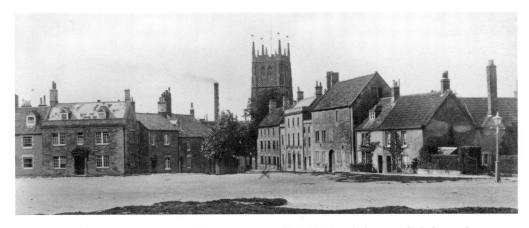

A postcard of the northern corner of The Green posted in 1933 by a lady named Thelma, who was then living in No. 1. The buildings remain basically the same. The biggest building on the right had been a woollen factory and by this time was used by Harris's as a sawdust store, then was quite recently converted into three flats. The surface of The Green is again mainly gravel. In the background can be seen Harris's chimney and the pennants on the top of the pinnacles on the Church Tower.

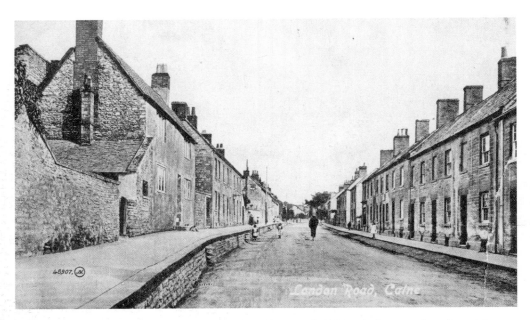

A Valentine's postcard shows the lower end of London Road. Although this must have been taken during the early years of the twentieth century, most of the houses seen remain structurally unchanged, as does the high pavement on the left.

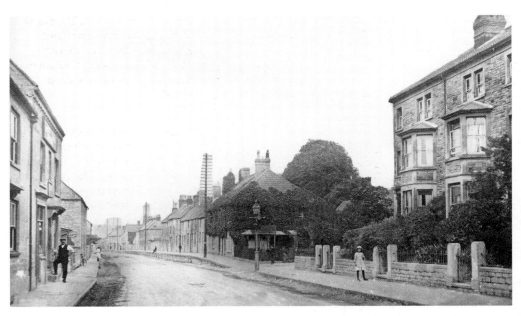

The same section of the street looking in the opposite direction, possibly at a slightly later date. Again, the buildings remain much the same today. The ivy-covered building in the centre on the corner of Shelburne Road was a commercial premises of some kind and, on the left, what is now the London Road Inn looks more like a shop. Tall telegraph poles with a multitude of arms have become a feature of the street scene.

For many years Back Road accommodated a Methodist chapel, which also had an access from London Road through a gap in the terrace houses. The Wesleyan Methodists built the chapel in around 1811. They remained there until they moved to the new church in Silver Street in 1876. The Back Road Chapel was bought by Thomas Harris ('bacon curer') who let it to E.W. Maundrell for his engineering and bicycle-making business. In 1886 the building again became a chapel when it was acquired by the Primitive Methodists who remained there until 1965, when they amalgamated with the Silver Street church. They were responsible for adding a Sunday school room which is the wing projecting towards the camera. The old chapel was acquired by a builder in 1981 who demolished it and built a pair of houses on the site.

Seen across a well-tended vegetable garden is this chapel in Bollings Lane, which is where Linden Close now stands with Back Road on the right. The chapel had a remarkable history. It may have been built about 1695 as a Presbyterian chapel. It then became Unitarian and so attracted Joseph Priestley when he was living in Calne as librarian for the Earl of Shelburne, 1773-80. It was later occupied by the Primitive Methodists until their move to Back Road. In the early twentieth century this chapel became the Salvation Army Citadel and it served as a forces canteen during the Second World War. After serving as an overflow classroom for Bentley Grammar School, it was demolished to make way for Linden Close.

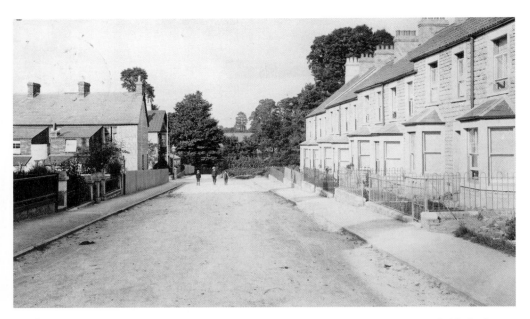

A postcard showing the eastern arm of Shelburne Road. The houses shown were probably built in the last twenty years of the nineteenth century. The photo, by H.R. Gross, was posted in 1922 but perhaps taken earlier.

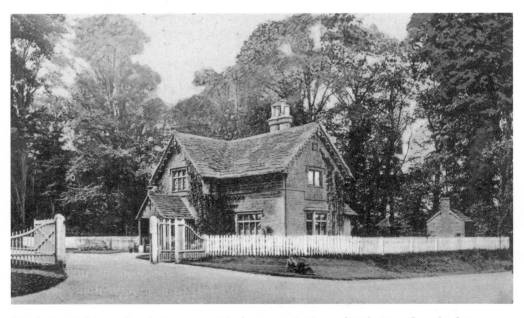

Wessington Lodge marks what was an original entrance to Bowood Park. Nowadays the driveway from here to Bowood is cut in two by the A3102, which was built as a turnpike in the 1790s, and so the drive from here to Pillars Lodge is no longer used as such, although it provides an important pedestrian access to the John Bentley School and the leisure centre. The lodge was built in the nineteenth century.

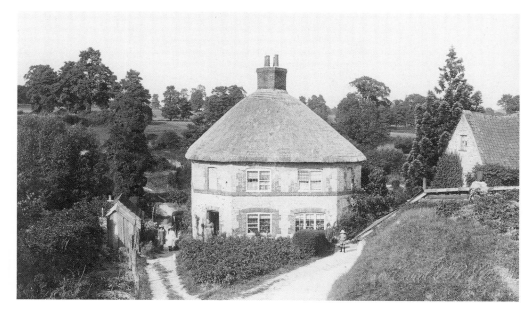

There was a mill, known as Hole Mill, on the river below what is now Roundhouse in Wessington Park from no later than 1663. It was used for various trades including fulling, clothing, mop-making and paper-making. It was disused by 1885. The clothing industry left this unusual building known as the Roundhouse, although in fact it was an octagonal drying stove for cloths and would have been full of drying racks. When that use ceased it was converted into three cottages. It later had a slate roof in place of the thatch. On demolition in the 1970s it gave its name to the road.

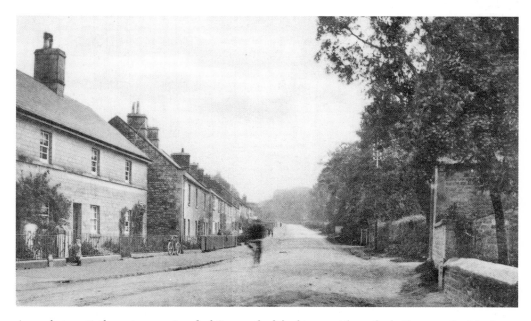

An early twentieth-century postcard of Quemerford, looking east from the bridge over the Marden outside Lower Mill.

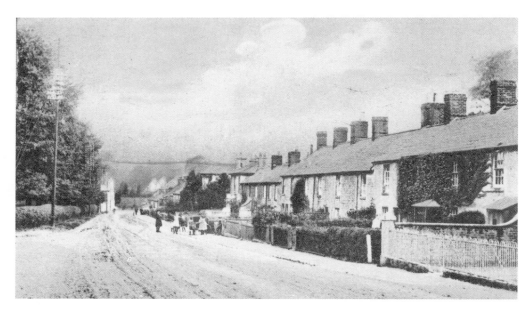

This postcard shows the same section of Quemerford looking west. It probably dates from the early 1920s although it was posted in 1944, which shows how posting dates cannot be relied on to date postcard scenes. The houses visible are still there but the Lakeview Estate has recently been developed on the left in place of Upper Mill and the one-time Rawlings & Phillips premises.

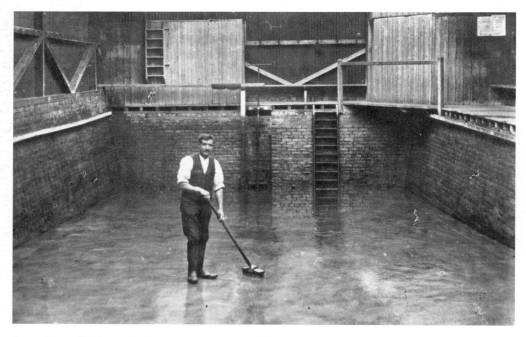

Reverting to the River Marden at Wessington Park, the Borough Council built a swimming bath on the river, which opened in June 1896. It was basically a pool filled by the river. Despite its gloomy appearance and the no doubt icy water of the Marden, the pool remained in use until around 1939.

5

AROUND THE TOWN

Bowood Estate built a number of farmhouses around the area in a recognisable estate style in the nineteenth century. This is Rough Leaze, a short distance along Stockley Lane.

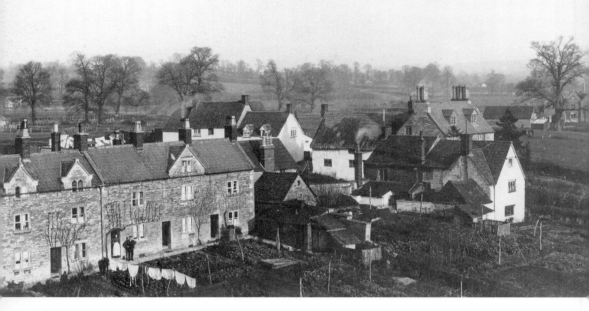

The lower end of The Pippin, *c.* 1900. The cottages in the foreground were demolished to make way for what is now the Somerfield car park. Some of those in the background remain. Beyond the houses was Coleman's Farm with its farmhouse on the right. There is open country dotted with elm trees where the Coleman's Farm Estate, Abberd Way and Prince Charles Drive now are.

Opposite above: An early twentieth-century view looking north from the church tower. The river in the foreground is full in order to work the mill on the left. In the centre is the cottage illustrated on page 43. Behind is the Recreation Ground with its lodge and, beyond, open fields which have now all been built over. The house on the left, with its gazebo in the garden, later served for many years as the vicarage but in 1775-80, when it was known as 'The Parsonage', it was the home of Joseph Priestley while employed by Lord Shelburne. A fishpond in the grounds may have been the 'Doctor's Pond' where Priestley carried out his experiments on oxygen.

Opposite below: Cow Lane, which we now know as Brewers Lane, looking towards cottages at the top end of Anchor Road. The cottages still exist but have all lost their thatch in favour of slates or tiles, except for the one with the facing gable. There are remarkable woven fences on each side of the road.

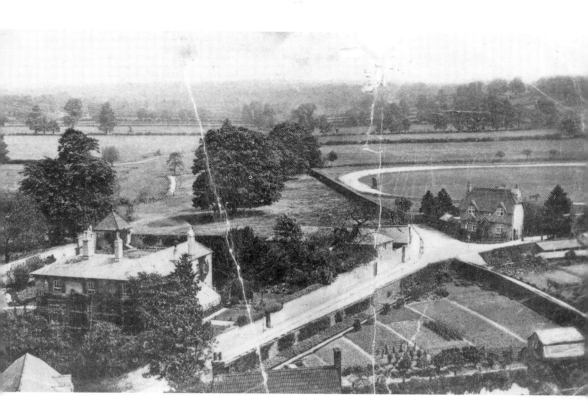

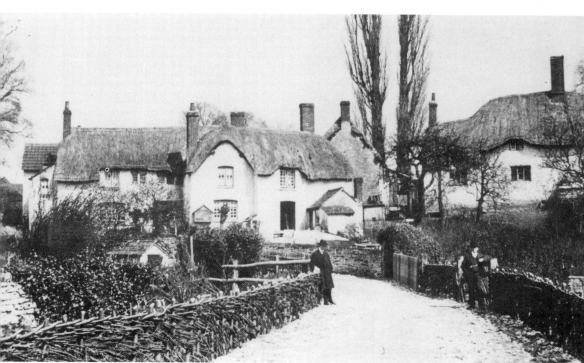

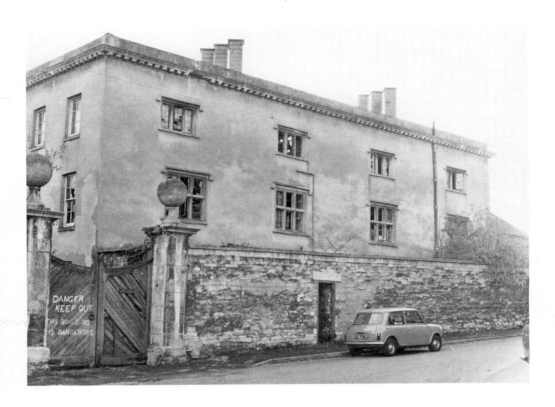

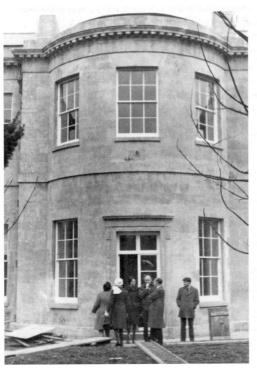

Above: Castle House consisted of what was probably a seventeenth-century wing overlooking Castle Street and a Regency wing overlooking the garden. For many years it belonged to one of the Harris family and was acquired by the Borough Council in 1961, but was left empty and damaged by fire in 1967. Thereafter the old wing was demolished and old people's accommodation built in its place. The photograph shows the seventeenth-century wing after the fire. Originally it had a gable over each bay but these must have been joined by the cornice and parapet to match the Regency wing when it was built.

Left: An inspection of the Regency wing of Castle House while the conversion work was being carried out, *c.* 1975. Councillor John Whiles and his wife, Phyllis, flank Civic Society Secretary Paul Buckeridge in the centre. The building is now divided into residential units and the Regency façade remains in good order. A fine seventeenth-century fireplace was rescued and can be seen at Market Hill House.

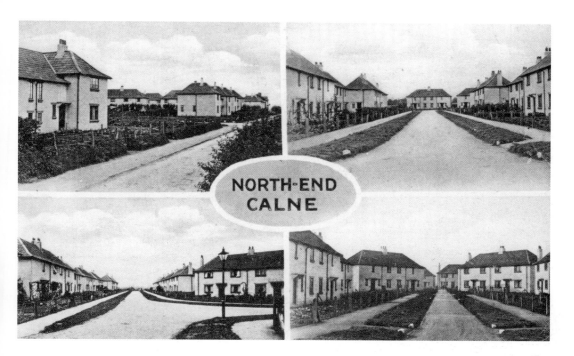

The Borough Council built its first housing estate with about sixty houses at North End in 1920-21. A further 100 were added by 1939 and more after the war. The composite postcard, posted in 1944, shows some of the pre-war development. After the war the Borough Council turned its attention to land on the east side of Lickhill Road and in 1954 bought part of Newcroft Farm. The postcard shows Newcroft Road in its early days. Subsequently, the whole of the area between Lickhill Road and Oxford Road was built up with council and private housing and schools.

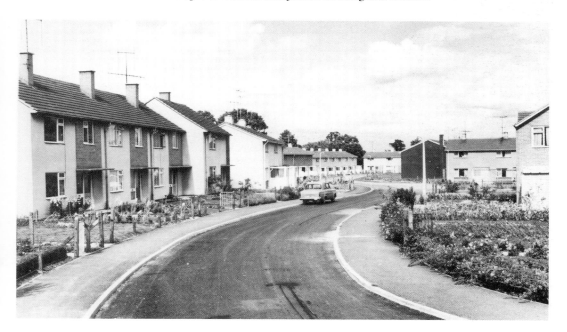

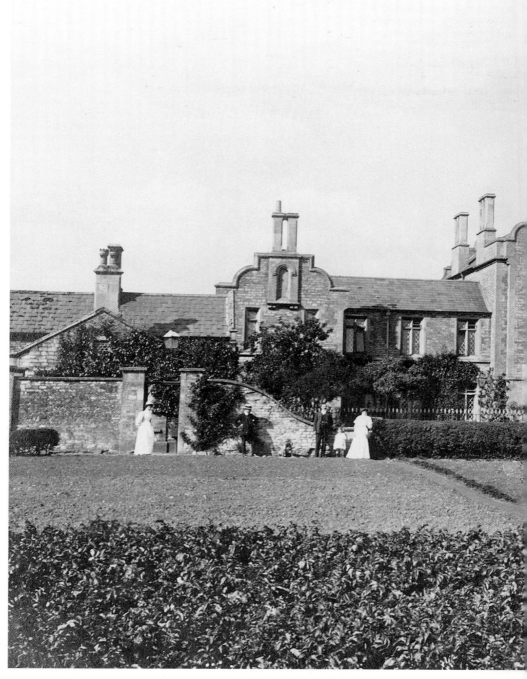

The union workhouse was built north of Curzon Street, *c.* 1847. It was designed to house the fit unemployed and those unable to keep themselves. As the photograph shows, it was a fine building in Jacobean style. No doubt the well-tended vegetable garden in the foreground was looked after by

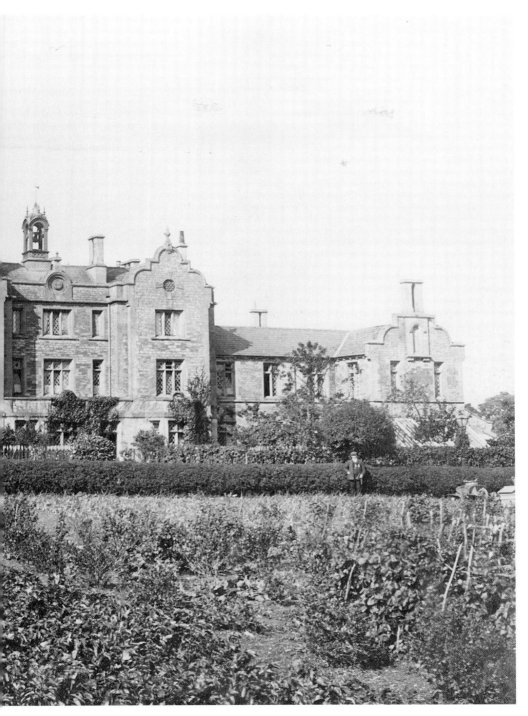

some of the inmates. With the introduction of a more humanitarian system the building became surplus to requirements; it and the surrounding land was purchased by St Mary's School in 1934 and the workhouse was demolished, with only the small lodge to the left of the picture surviving.

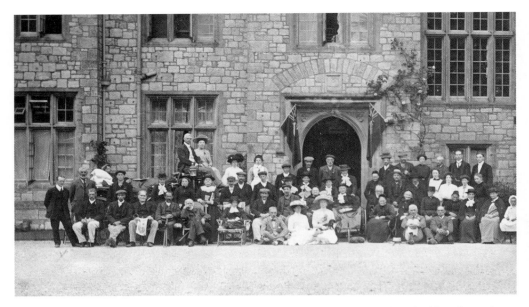

This intriguing old postcard is believed to show the workhouse. As the details of the building do not fit with the previous photograph, it was possibly taken on its other side. Clearly some special occasion in the Edwardian period is being celebrated as is indicated by some of the ladies' attire and the flags hanging by the door. Very probably the picture shows the full number resident in the workhouse at the time.

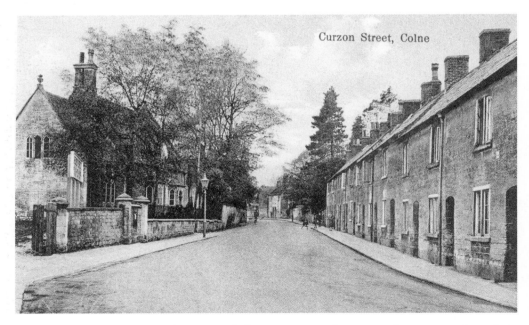

An undated postcard showing the outer end of Curzon Street. The terrace of cottages on the right is still there but the house on the left has been demolished to make way for a car sales area and part of Curzon Close. In the distance there is the entrance to St Mary's School, where the cottage fronting the road has been demolished.

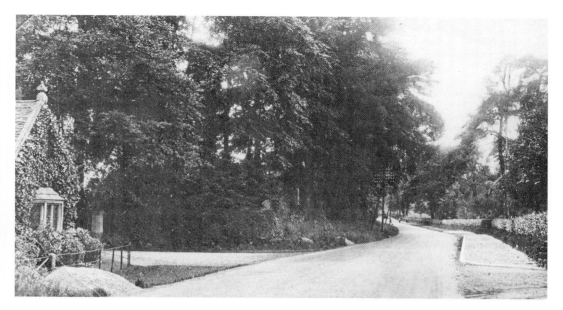

Turning to the Chilvester area, this view looking out from the town is on a postcard posted in 1934 showing Chilvester Hill looking like a tree-lined avenue. The lodge on the left marked the entrance to Castlefields House whose grounds were subsequently developed as Curzon Park.

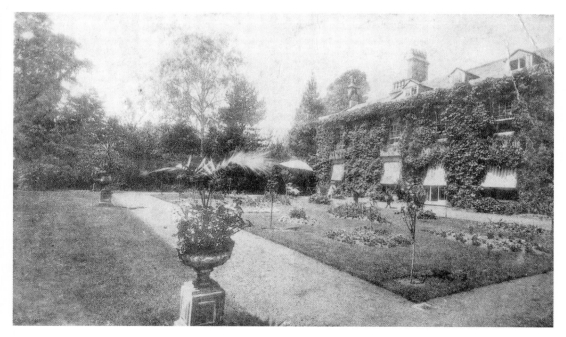

The north side of Chilvester Hill was (and is) lined with villas, built to house the more prosperous of Calne's inhabitants from the eighteenth century onwards .This card by J.J. Hunt, posted in 1907, shows Chilvester Lodge, heavily overgrown with creepers and displaying the sun blinds much beloved of the Edwardians.

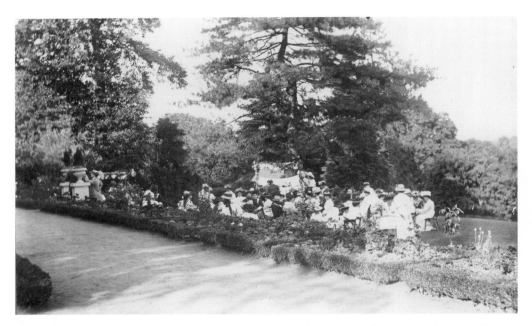

The Highlands was another large nineteenth-century villa, this time on Silver Street, where it still stands, although it is now called Vernleaze. This photo by Harold Gross was probably taken in its grounds. There is nothing to indicate what the event was. It seems to be attended mainly by well-dressed ladies. In the early twentieth century it was owned by Mrs Murray, who was a major benefactor of St Mary's School, with the result that school prizegivings were held there; perhaps this is one.

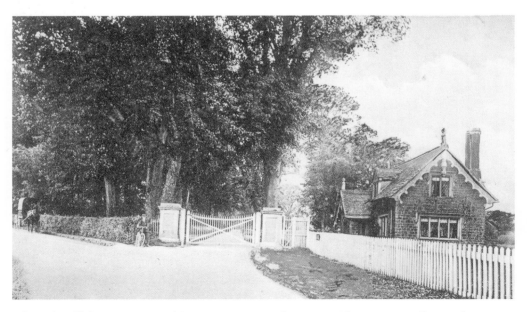

Where the old drive into Bowood from Wessington Lodge crosses Silver Street is Pillars Lodge, seen here on an early postcard. The Lodge with the two gate pillars which give it its name is still there but the pillars have been moved back and the road has been widened.

6

PEOPLE

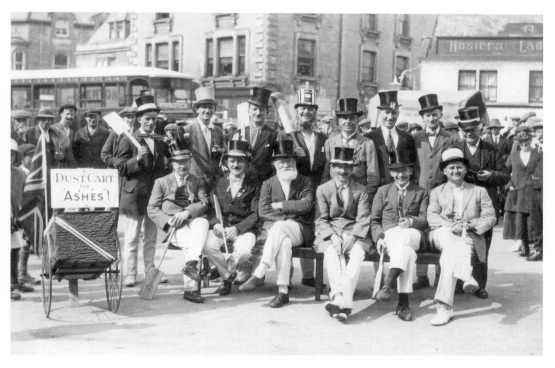

This photograph appears to have been taken during Shopping Week in 1926. It shows a crazy cricket team posing on The Strand, probably composed largely of local tradesmen, with their dustcart for the ashes.

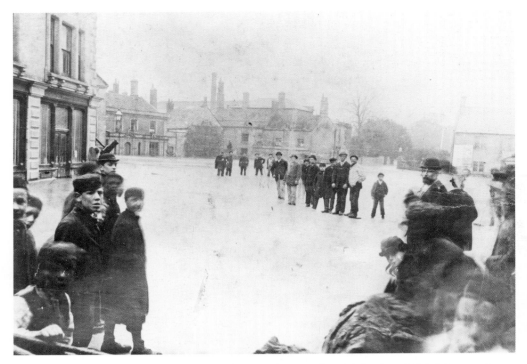

A fascinating old photograph showing flooding on The Strand on 24 October 1882. It is a good study of male dress of the period, but of special interest is the building on the right which is the old town mill, shortly before it was demolished to make way for the new Town Hall. Behind the central group of spectators are buildings in the Harris premises; on their left is the building which preceded the present Bank House.

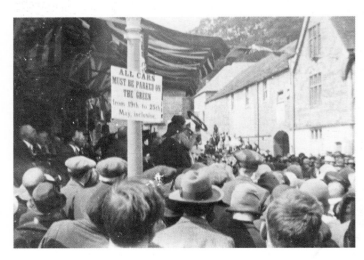

A gathering outside the Town Hall for one of the Shopping Week events. The big key which symbolises the event (which can now be seen in the Heritage Centre) is being held up in the centre. It is interesting that the notice on the lamp-post implies that there will be sufficient room on The Green for any cars which needed to park. The date is probably mid-1920s.

Opposite: These photographs came to me from the Wiltshire family and no doubt include some unidentified members of that family, taking part in a parade in the town, *c.* 1930.

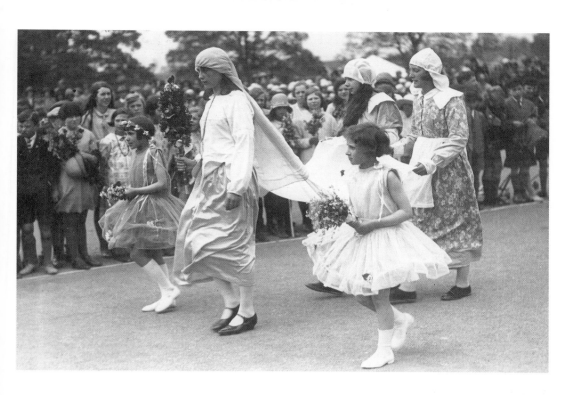

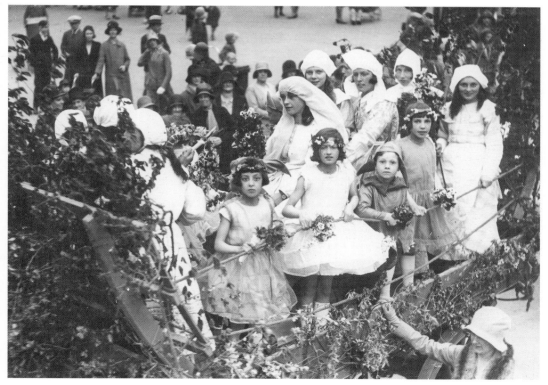

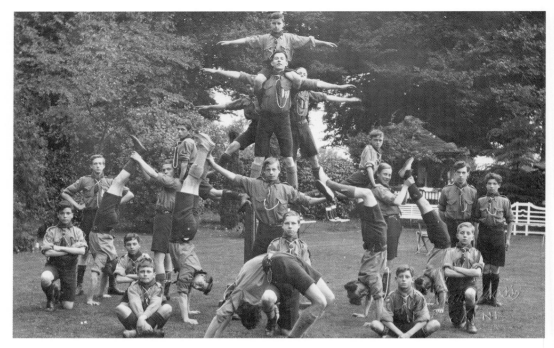

An Edgar Gross postcard of the Boy Scouts posing acrobatically, perhaps in the mid-1920s.

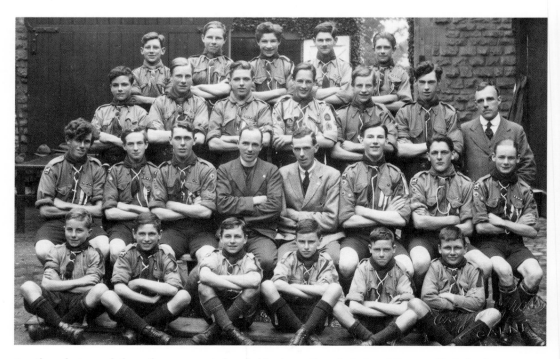

Another photograph from the same period probably shows the whole Scout Troop with its leaders, including a clergyman.

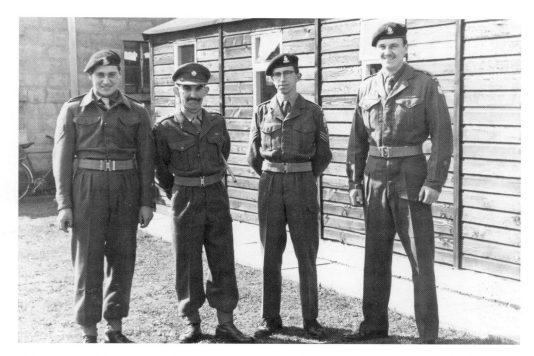

This photograph is marked as showing an annual inspection in 1956, presumably of the Cadet Force, when the B Company Staff HQ consisted of, from left to right: Sergeant Daniels, Captain David Buckeridge, Staff Sergeant Daniels and CSM Broome.

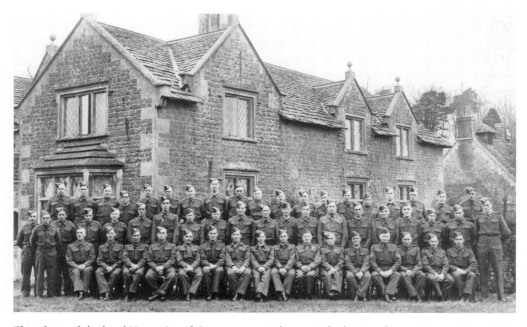

This photo of the local Home Guard Company was taken outside the Lansdowne Arms at Derry Hill in 1941.

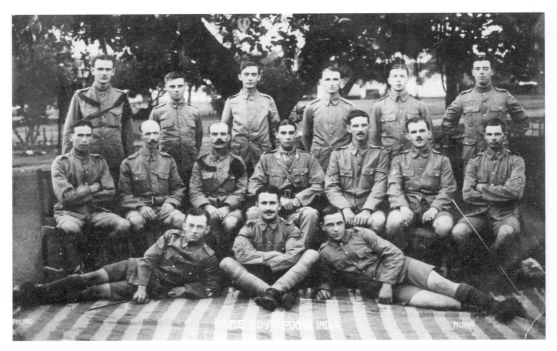

This unusual postcard shows a group of soldiers entitled 'Calne Boys Poona India'. Unfortunately, nothing more is known of the circumstances or the identity of the men, who may perhaps have been serving with the Wiltshire Regiment.

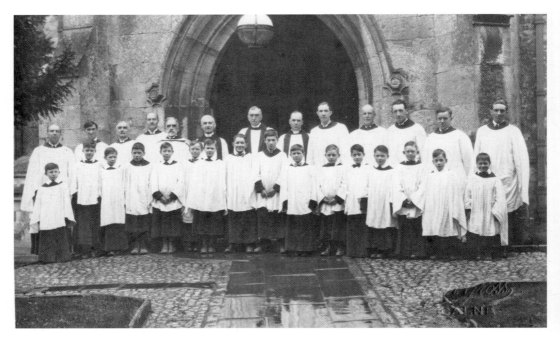

The Calne Parish Church Choir standing outside the northern porch of St Mary's Church in 1927.

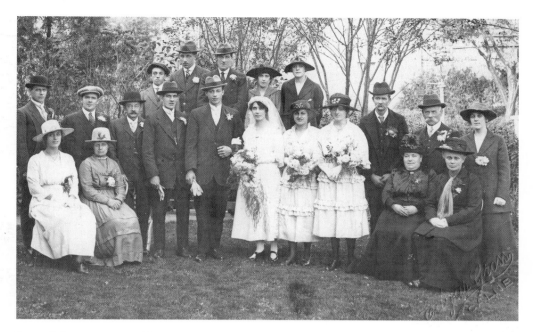

It is sad that so many wedding groups have no information recorded about them. Nevertheless, they provide a fascinating study of changing fashions and wedding arrangements. No doubt this Edgar Gross card can be dated by the fashions being worn. When did trilby hats come into fashion for men? I guess it to be the early 1920s.

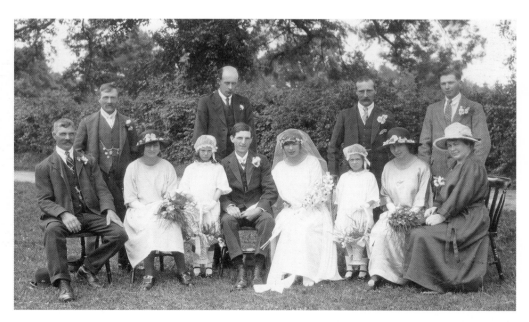

A more modest wedding group, possibly at a slightly later date. The men, all bare-headed, are wearing their ordinary suits. On the back is pencilled, 'To Auntie Annie and Uncle Tom... from Betty and George'.

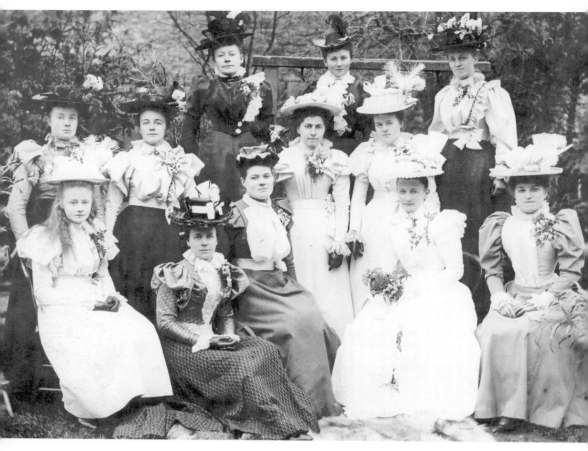

This is apparently also a wedding group although it consists entirely of women, with the bride second from right at the front. It appears the two bridesmaids are behind her and all the rest are likely to be relations. The headgear is amazing. This photograph was taken by J.J. Hunt of Calne, *c*. 1900.

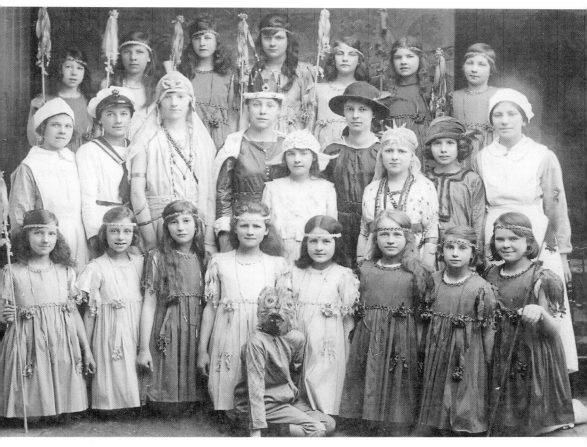

A group of fine looking children in fancy dress photographed by Edgar Gross. They may have been dressed for the carnival but the date is unknown, probably early 1920s.

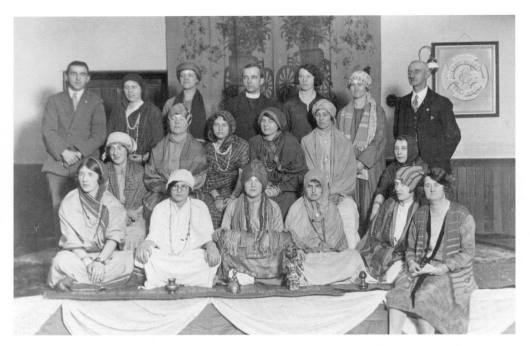

This photograph is fortunately accompanied by a newspaper cutting stuck on its back. The group had performed 'A Brahmin Marriage' in the Wesleyan school room at Melksham, although the group were 'the Calne Girls' Own assisted by local friends'. 'A Brahmin Marriage' was in eight scenes with a solemn finale provided by the audience singing 'Can we whose souls are lighted'. 'The whole thing was well done and reflected credit on all who took part'.

A less solemn dramatic production in the Town Hall, probably in the early 1950s. The production is unknown but Kenneth Dixon is third from the left and Cameron Gough third from the right.

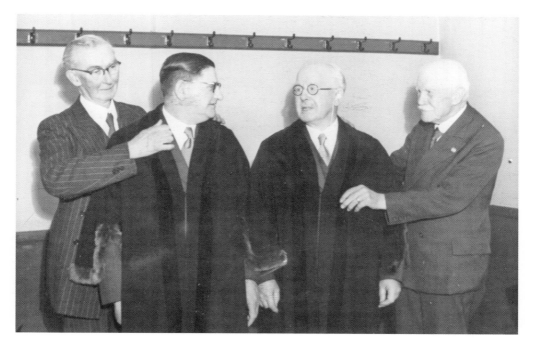

A somewhat studied picture taken in the Town Hall in the early 1950s showing four one-time Mayors of Calne. From left to right: B.I. Dixon, Cyril H. Thomas, W.J. Morment and F.J. Gale.

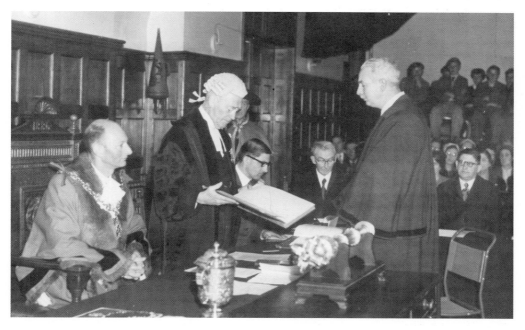

The Mayor-making ceremony of 1955 in the Town Hall. Being sworn in is Mr B.C. Elliott. Facing him are, from left to right: Jack Wiltshire (outgoing Mayor), C.O. Gough (Town Clerk), Leonard Cave (Deputy Town Clerk), B.I. Dixon and C.H. Thomas (both former Mayors).

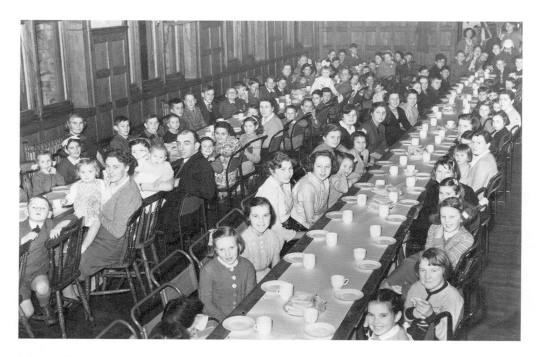

Two photographs of a children's tea party in the Town Hall. There is nothing to indicate the occasion or the date. It may have been Christmas or some special event like the Coronation. However, there will surely be some readers of this book who recognise themselves and can identify the occasion, which, to judge by the children's appearance, was not too long after the Second World War.

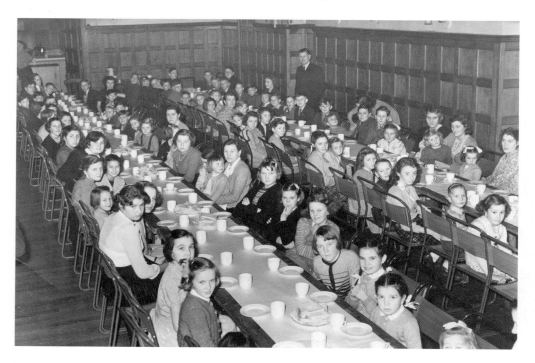

A bazaar or jumble sale in the Town Hall, *c.* 1950s. It was organised by Mrs Millie Dixon, bottom left, probably in aid of the Red Cross or a similar charity. Also recognisable is Bernard Dixon, in the trilby in the centre, and, right of centre, facing left in the dark hat is Miss Mary Sutton. Again, readers may be able to recognise themselves and identify the occasion.

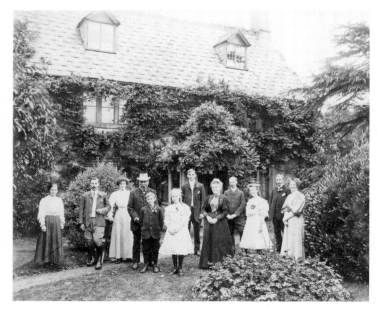

A splendid family group photographed in about 1908 at Sands Farm, Low Lane. It shows Frederick Smith and his wife surrounded by their children. Dorothy, on the left, was a nurse at the workhouse. The girl in the centre was Alice, later Mrs Chalu, who became a sister at St Thomas's Hospital in London. The members of the family were identified to me by Miss Win Smith, who died fairly recently and was the daughter of Arthur, second right.

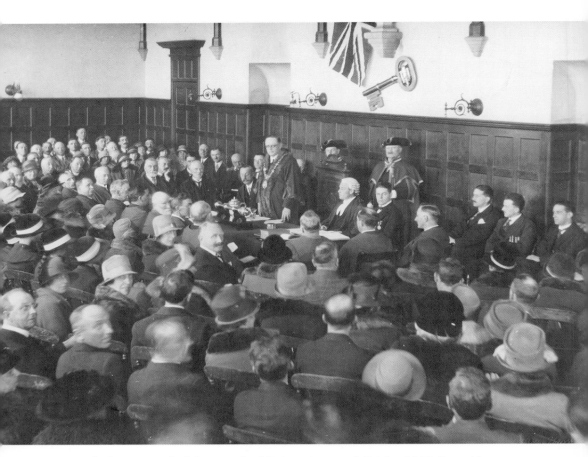

A view inside the Town Hall of the second public investiture on 9 October 1927. It would seem that before 1926 there was no formal public ceremony for the enrobing of the new Mayor (it being the practice of the Borough Council to elect a new Mayor annually). John Bodinnar, Mayor in the picture and managing director of Harris's, was a great innovator and was no doubt responsible for introducing the public investiture, or Mayor-making as it has become known. To his left is the Town Clerk, Mr Charles Ogle Gough, and in front of the Mayor are the silver gilt mace (which he had just presented to the Council) and the silver loving cup which the Earl of Shelburne had presented in November 1926, although it had been made in Newcastle in the mid-eighteenth century. The famous Shopping Week key hangs on the wall.

7

EDUCATION AND RECREATION

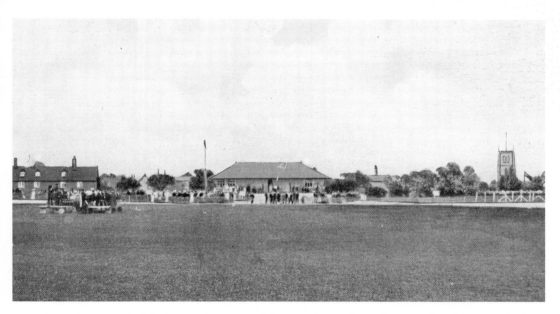

An early postcard of the Recreation Ground showing the pavilion. The ground and its caretaker's house were provided as a gift by Mr Thomas Harris in 1890.

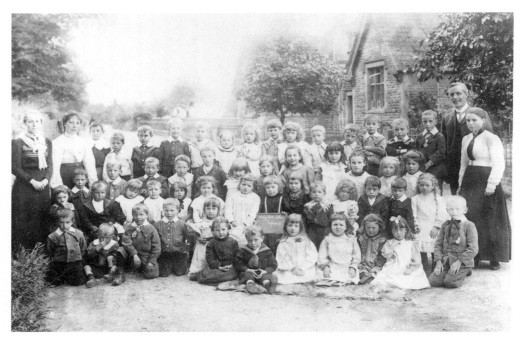

Derry Hill Infants' School in the early twentieth century.

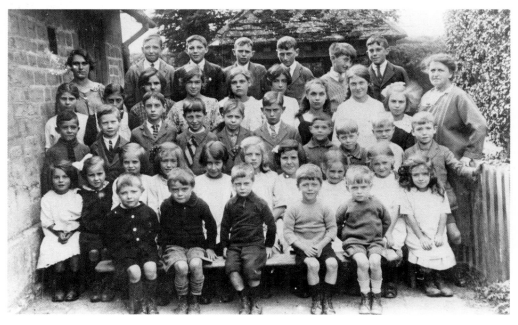

Calstone School in the 1920s. It is surprising that such a small village produced so many children. The fact that it could not now do so is an indication of the decline in the demand for agricultural labour since that date. However, the school served Blacklands as well as Calstone. A new school, which survives as a dwelling house, was built in 1860 and closed in 1963.

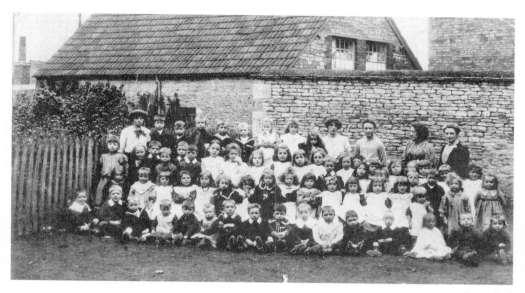

The Guthrie Juveniles School, as it was known and is described on this postcard, was opened to the west of Wood Street in 1854. The school, by then an infants' school, moved to William Street in 1964. Despite its lack of vehicular access, the building survives in use as a sculptor's studio.

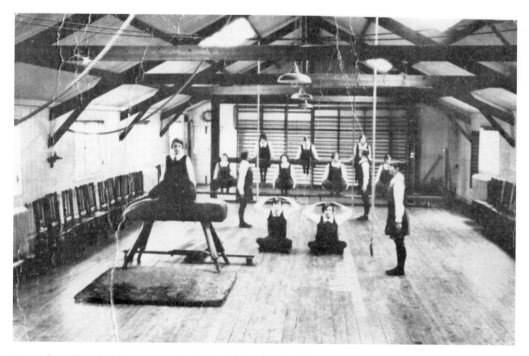

A number of postcards were produced of St Mary's School between the wars. The school had been founded in 1873 and was originally accommodated on The Green. The school moved to new premises, where it has since expanded, in Curzon Street in 1908. This somewhat battered postcard shows the gymnasium.

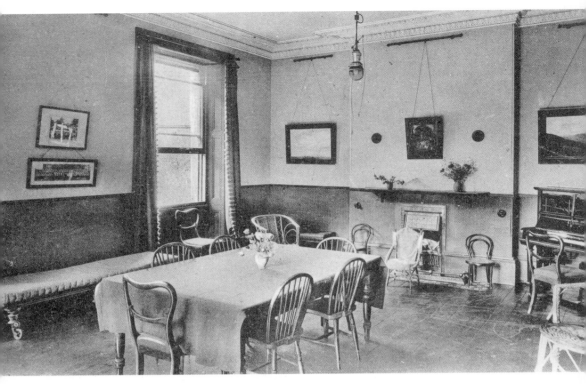

It became the practice to name rooms in the school after benefactors. Miss Ellinor Gabriel was both a founder and major benefactor of the school and the sitting room illustrated was named after her.

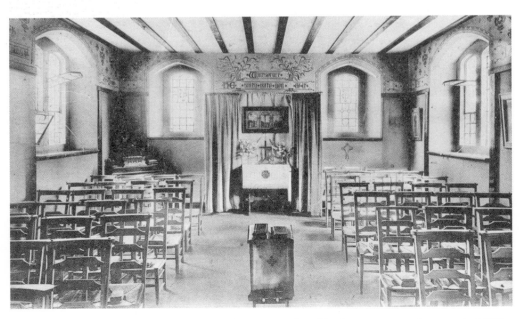

The early school chapel at St Mary's shown here was replaced by the existing modern one in 1972.

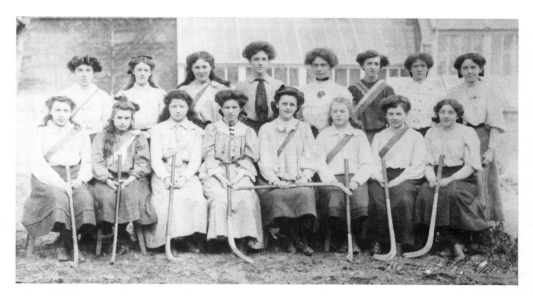

A formidable looking Calne Secondary School girls' hockey team, *c.* 1904. These names are recorded; back row, from left to right: Mabel Cleverly, Dorothy Fell (daughter of the manager of the gasworks), Mrs Reg Burden, Edith Priscilla Maundrell (daughter of Edward Ward Maundrell of the foundry, Horsebrook), Mrs J. Sorensan, Dorothy Gough (later Mrs C. Child, sister to Mr C.O. Gough, Town Clerk of Calne), a teacher, Louisa Jane Maundrell (sister to Edith, Mrs L.J. Buckeridge). Front row: Dorothy Keevil, Grace Rumming, Hilda Hillier, Hilda Wood, Madge Gough (Mrs E. Whitby, sister of Dorothy) Joan Pocock, Edith Smart, Ella Mary Maundrell (sister of Edith).

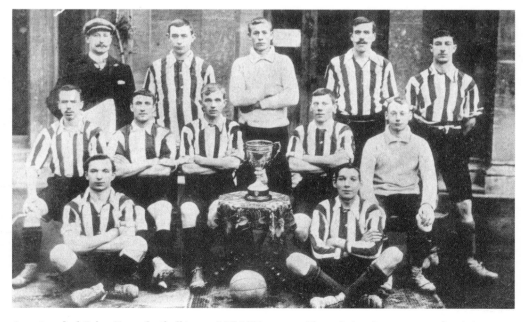

A postcard of Calne Town football team, 1905/06 season. They obviously won a cup, but it is not stated which.

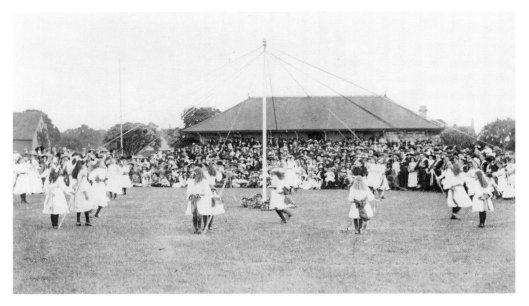

An Edward Gross postcard of maypole dancing on the Recreation Ground in Edwardian times. The crowd massed on the pavilion steps are sporting an amazing collection of hats.

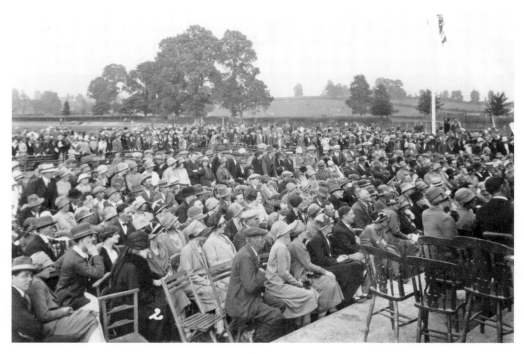

For a while in the 1920s and '30s, a Dunmow Flitch Trial was held, usually in conjunction with the Shopping Week. The couple judged to have lived in the greatest harmony was awarded a side or flitch of Harris bacon. The photograph shows the crowd eagerly watching the proceedings in the Recreation Ground in 1930.

Calne Carnival Shopping Week,
19th to 25th May, 1927.

VERY SPECIAL ATTRACTION
Most Astounding Lawsuit ever known in Calne!
TRIAL FOR THE WILTSHIRE FLITCH
(kindly presented by C. & T. Harris (Calne) Ltd.)

WILL TAKE PLACE IN THE

Recreation Ground, Calne,
(and if wet in the Pavilion)

At 6 p.m. on Wednesday, 25th May, 1927.

The Court will be constituted as follows:—
Judge—
G. A. Wilshire, Esq., (Bristol).

Counsel for the Flitch and for the Applicants:—

F. E. Metcalfe, Esq., (Bristol)	Leslie Pullen, Esq., (Bristol)
W. F. Long, Esq., (Bath)	J. Guy Neal, Esq., (Bristol)
R. E Pullen, Esq., (Bristol)	C. O. Gough, Esq., (Calne)
	Miss Wilshire, (Bristol)
	and other eminent Counsel

Clerk of the Court—B. Spackman, Esq.

and a Jury composed of local spinsters and bachelors.

The Flitch of Bacon will be awarded to the couple who can prove to the satisfaction of the Court that they have lived happily together with no quarrels during the past year.

COME TO THE CALNE ASSIZES!

ENTRIES INVITED which should be addressed, without delay, to
Mr. F. C. HUNT, High Street, Calne.

Details of the Flitch Trial, as shown on this page from the Calne Carnival Shopping Week booklet of 1927.

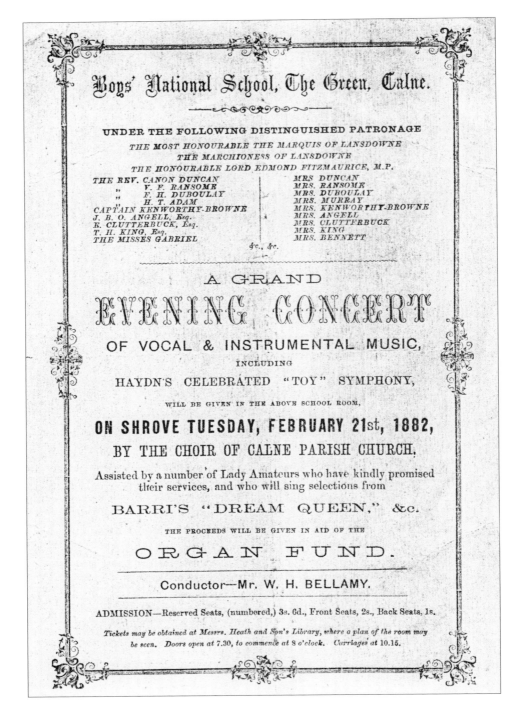

Boys' National School, The Green, Calne.

UNDER THE FOLLOWING DISTINGUISHED PATRONAGE

THE MOST HONOURABLE THE MARQUIS OF LANSDOWNE
THE MARCHIONESS OF LANSDOWNE
THE HONOURABLE LORD EDMOND FITZMAURICE, M.P.

THE REV. CANON DUNCAN	*MRS DUNCAN*
„ *V. F. RANSOME*	*MRS. RANSOME*
„ *F. H. DUBOULAY*	*MRS. DUBOULAY*
„ *H. T. ADAM*	*MRS. MURRAY*
CAPTAIN KENWORTHY-BROWNE	*MRS. KENWORTHY-BROWNE*
J. B. O. ANGELL, Esq.	*MRS. ANGELL*
E. CLUTTERBUCK, Esq.	*MRS. CLUTTERBUCK*
T. H. KING, Esq.	*MRS. KING*
THE MISSES GABRIEL	*MRS. BENNETT*

&c., &c.

A GRAND

EVENING CONCERT

OF VOCAL & INSTRUMENTAL MUSIC,

INCLUDING

HAYDN'S CELEBRATED "TOY" SYMPHONY,

WILL BE GIVEN IN THE ABOVE SCHOOL ROOM,

ON SHROVE TUESDAY, FEBRUARY 21st, 1882,

BY THE CHOIR OF CALNE PARISH CHURCH,

Assisted by a number of Lady Amateurs who have kindly promised
their services, and who will sing selections from

BARRI'S "DREAM QUEEN," &c.

THE PROCEEDS WILL BE GIVEN IN AID OF THE

ORGAN FUND.

Conductor—Mr. W. H. BELLAMY.

ADMISSION—Reserved Seats, (numbered,) 3s. 6d., Front Seats, 2s., Back Seats, 1s.

*Tickets may be obtained at Messrs. Heath and Son's Library, where a plan of the room may
be seen. Doors open at 7.30, to commence at 8 o'clock. Carriages at 10.15.*

In past years Calne produced much locally-generated entertainment. This advertisement was
for a concert (rather unusually) in the Boys' National School on The Green. The organ fund
must have been for the new organ installed in St Mary's Church in 1882. However, it lasted
only until the present organ was installed in 1908.

TOWN HALL, CALNE,

(By permission of the Worshipful the Mayor.)

UNDER THE PATRONAGE OF
THE MOST HONOURABLE THE MARQUIS OF LANSDOWNE.
THE MARCHIONESS OF LANSDOWNE.
THE RIGHT HONOURABLE LORD CREWE.
LORD EDMOND FITZMAURICE, M.P.
THE REV. CANON DUNCAN, VICAR OF CALNE.
AND THE CLERGY AND GENTRY OF THE NEIGHBOURHOOD.

THE MEMBERS OF THE

CALNE AMATEUR DRAMATIC SOCIETY

Beg to announce that they intend giving

Two Dramatic Entertainments

ON THE EVENINGS OF

TUESDAY and WEDNESDAY, 18th and 19th APRIL, 1882,

IN AID OF THE

Parish Church Organ Fund,

CONSISTING OF

The PETIT COMEDY in two Acts, adapted from the French
by CHARLES MATTHEWS, entitled

"USED UP;"

CONCLUDING EACH EVENING WITH A

VERY LAUGHABLE FARCE.

The **ORCHESTRAL BAND** will play a Selection of Operatic
and other Music under the leadership of **Mr. J. J. LANE.**

Admission on first Evening—Dress Circle, 3s. 6d., Reserved and Numbered Seats, 2s. 6d.,
Back Seats, 1s. Wednesday Evening, Reserved Seats (numbered,) 2s. 6d., Second
Seats, 1s. Tickets taken and Plan of Room at Messrs. A. Heath and Son's.

Doors open at 7.30 o'clock. Overture at 8. Carriages ordered at 10.30.

Cloak Room Entrance opposite the Bank.

To facilitate arrangements an early application for tickets is respectfully requested.

Programmes may be had in the Room, 2d. each.

1882 was a good year for entertainment, perhaps because of the organ fund. This leaflet advertises an evening entertainment by the Calne Amateur Dramatic Society in the Town Hall. This must have been in the old hall not long before it was demolished. The seating arrangements seem to have been elaborate.

What is probably the Bowling Club posed in the Recreation Ground in the 1930s. Two members of the Wiltshire family are identifiable: Henry Wiltshire is second from the right in the third row from the front and his son, Jack, is third from the left in the front row.

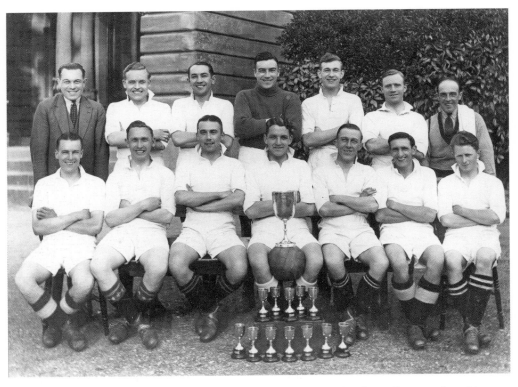

A later Calne football team, this one from the 1933/34 season, with a fine collection of trophies.

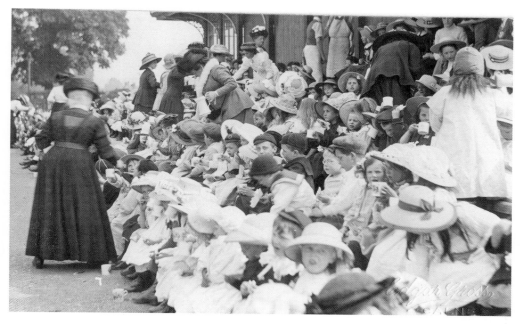

An Edgar Gross photo of children massed on the steps of the pavilion in the Recreation Ground for some major celebration in the Edwardian era. Plenty of mugs of drink are in evidence.

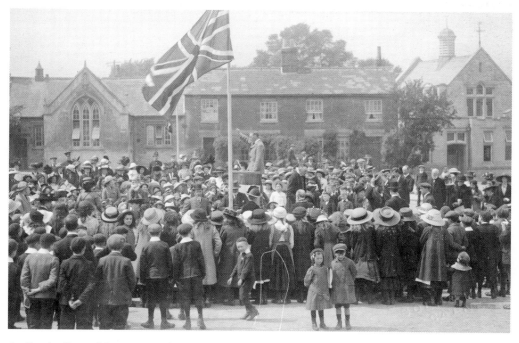

An Empire Day celebration on The Green, *c.*1910. The conductor on the central stand is Mr E.O. Pound. Behind him, facing away, is Archdeacon Boddington, Vicar of Calne. In the background are the Girls' National School on the left and the Grammar School on the right.

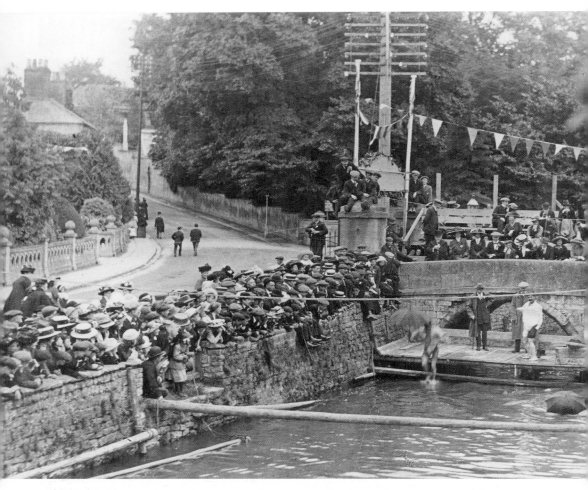

A wonderful photograph of water sports in the River Marden during the Coronation celebrations in 1911. Those holding umbrellas are leaping into the icy water of the Marden from a temporary bridge or pontoon. The water is at the level at which it was maintained when this section of the river formed the final stretch of the canal, although canal traffic has ceased by this date. Although boaters were fashionable, formal clothing seems to have been rather dark at this time.

8

TRADE, INDUSTRY
AND AGRICULTURE

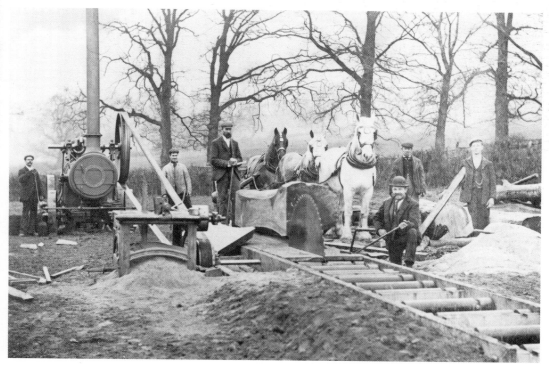

Messrs Beints' saw milling outfit, perhaps at Studley or in Calne. A portable steam engine (i.e. one which was not self propelled) is turning a belt which is driving a large rotary saw, against which a big log is being pushed to cut it into planks. The horses must have been involved in haulage, not in the sawing process.

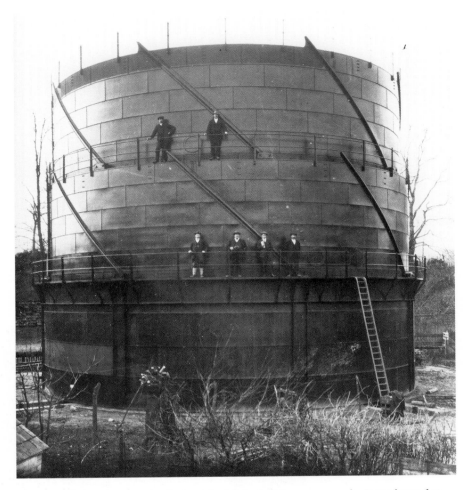

Above: People are often surprised to learn that Calne had its own gasworks. It was located at the bottom of Horsebrook where flats and houses now stand. The picture was probably taken to commemorate the completion of the building of the gasholder. The view is taken across the Marden with the grounds of Horsebrook House, now Horsebrook Park, in the background. The works were established as early as the 1830s. The provision of the gasholder was probably an improvement made in the early 1920s by the contractors Blackford & Son. From 1939, gas was piped in from elsewhere and the works were demolished by the mid-1960s.

Opposite above: Invoice by the Calne Gas & Coke Co. Ltd to the Calne Co-operative Society, recorded on 31 December 1904. 7,000 cu. ft of gas cost about £1.38 and even then there was a small discount.

Opposite below: The gas company promoted its wares. This decorated lorry probably took part in a Shopping Week Carnival in the 1920s. The notice above the cab reads, 'Note recipe for the Wiltshire Fitch, Home Sweet Home. There is only one thing more my lads, wherever you may roam, if you use GAS for everything, YOU'LL have a HAPPY HOME'. The people may have been characters in the carnival; Charlie Chaplin is identifiable. The location is outside the pair of brick villas in New Road.

No. 295

The Gas Works, Calne, Quarter ending 31st December, 1904.

Messrs Calne Cooperative Society

Dr. to the Calne Gas & Coke Co., Ltd.

HEATH, PRINTER AND BOOKSELLER, CALNE.

	£	s.	d.
7000 Cubic Feet of Gas at 3/11½ per thousand	1	7	8½
Rent of Meter			6
Rent of Cooking Stove			
Coke T. C. Q. at per ton.			
Tar gallons at per gall.			
Account to 30th September, 1904.	1	8	2½
		1	4½
Discount 1/4½ Total £	1	6	10

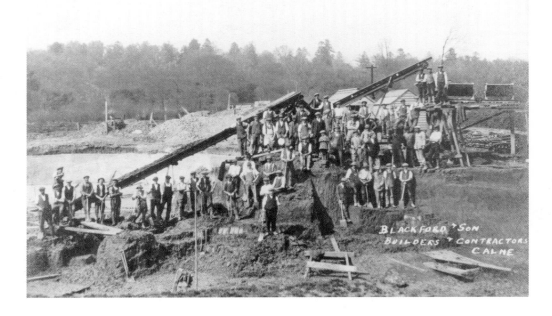

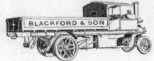

BLACKFORD & SON,

Builders, Contractors,

Undertakers, Monumentalists,

Plumbers and Decorators,

Works { SHELBURNE ROAD, LONDON ROAD, } Office { LONDON ROAD.

Telephone 53 **C A L N E .** Telegrams: Blackfords, Calne.

Church Work, Country House Extension, and Renovations a Speciality.

Having a large Staff of highly skilled mechanics we execute works of all descriptions at short notice, and at reasonable prices.

JOBBING WORK IN ALL BRANCHES PROMPTLY ATTENDED TO.

General

Haulage

Contractors.

Heavy Steam Haulage on Rubber Tyres any distance.

M E M O R I A L S T O N E S

IN GRANITE, MARBLE OR PENNANT WORKED TO ANY DESIGN, OLD MEMORIAL STONES CLEANED AND RENOVATED.

Estimates Free.

Above: Another photograph from the Blackford & Son archive. A very large workforce is seen enlarging the sewage works at Conigre, west of Calne. The works had been established there in the nineteenth century after a very long struggle to establish a sanitary sewage system in Calne. The equipment on view includes two elevators and a raised railway with tipper trucks.

Left: Blackford & Son was a substantial building and contracting firm. The extent of their activities is shown by this advertisement from the 1927 Shopping Week booklet. Part of their site at Quemerford is still occupied by their successor company, Wessington Cabins.

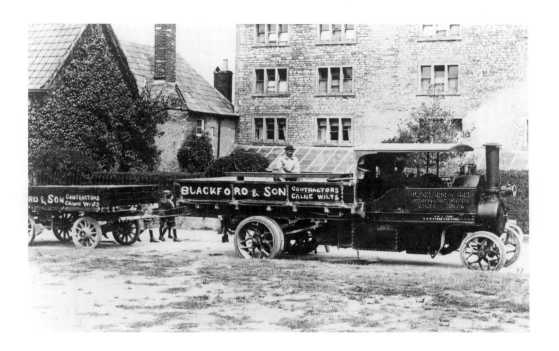

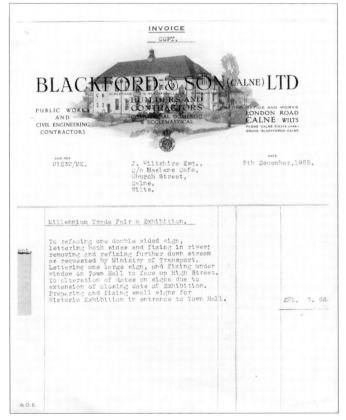

Above: Echoing the steam lorry shown in the last advertisement, this photograph shows such a lorry and trailer outside 'The Orphanage' on The Green. The wording on the lorry and trailer must have been written onto the negative. The actual sign on the side of the engine is illegible.

Left: A bill issued by Blackford & Son in 1955. The bill heading is illustrated by the Marcia Williams block at St Mary's School, which had been opened in 1930 and for which Blackford's must have been the contractors. Interestingly the bill is addressed to Mr Jack Wiltshire at Maslen's Café (which was owned by the Wiltshires) and relates to preparing signs for the Millennium Trade Fair and Exhibition, which took place in 1955 to commemorate the 1,000 years since the first written mention of Calne in the will of King Edred.

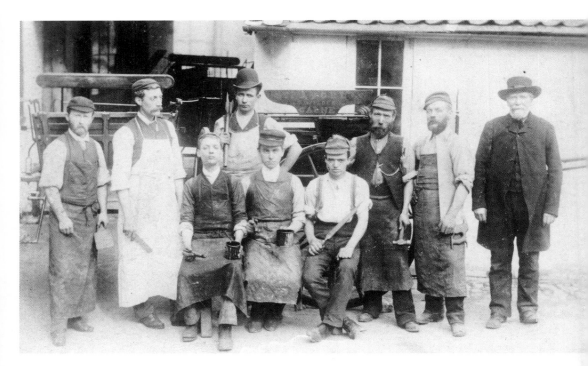

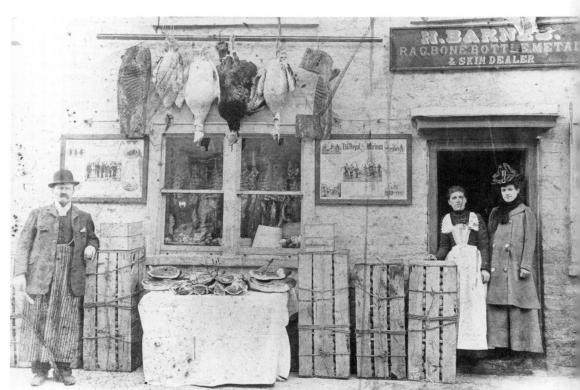

Opposite above: An early photograph of a Calne businessman and his workforce. The name 'Pavord, Builder, Calne' can be made out on the board on the wagonette. Messrs Pavord and Channon traded in Wood Street as cartwrights from 1869 to 1879, followed by David Pavord at No. 4 Wood Street from 1885 to 1903. The photograph probably belongs to the later period. The men's trades are identified by the tools they are carrying, e.g. scraper, ruler, paintbrush and pot, file, hammer and saw.

Opposite below: Another early photograph of a Calne business, this being H. Barnes, rag and bone, bottle, metal and skin dealer. He also seems to be a butcher with birds and meat on show. This is said to be a Christmas display in 1888. The shop was in London Road where the modern shops now stand just before the junction with Silver Street. The framed posters on the wall seem to be promoting the Royal Navy and the Royal Marines.

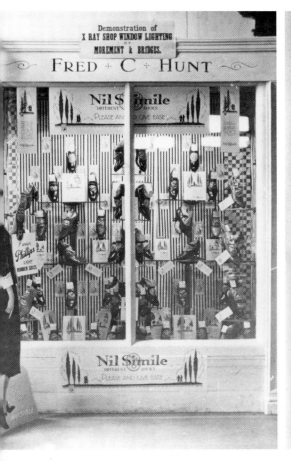

Fred C. Hunt had a shoe shop at No. 19 High Street. The photograph shows the window illuminated in a demonstration of x-ray window shop lighting by Morement & Bridges. The advertisement is from the 1927 Shopping Week booklet.

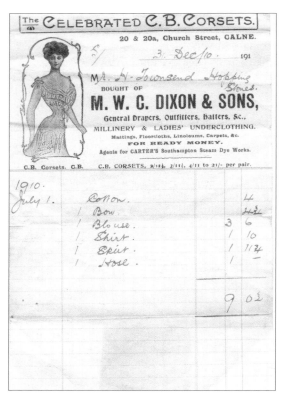

Dixon's drapers and outfitters operated for many years in a large shop in Church Street (now occupied by H.M Furniture). The invoice, dated 31 December 1910, has a striking picture of the restricted waist forced upon ladies by corsetry at that time. Fortunately, the items sold seem to be less restrictive. The photograph probably dates from the 1920s with a fine display of ladieswear, in particular the hats. The shop can be identified by the curve of the window towards the central opening, which was a feature of the premises for many years.

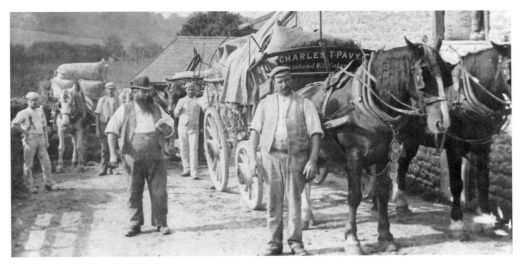

The mills on the River Marden formed an important part of the local economy. There were well over a dozen in the short distance between Calstone and Stanley. Many of them were concerned with the woollen industry but others were traditional grain or grist mills. This wonderful photograph was taken of Hazeland Mill in 1912. The fine wagon bears the name of the miller, Charles T. Pavy. Hazeland had in earlier years been both a woollen and a grist mill but was probably grist only from the 1830s. It remained in use until the late 1960s and is still in working order with a water turbine drive.

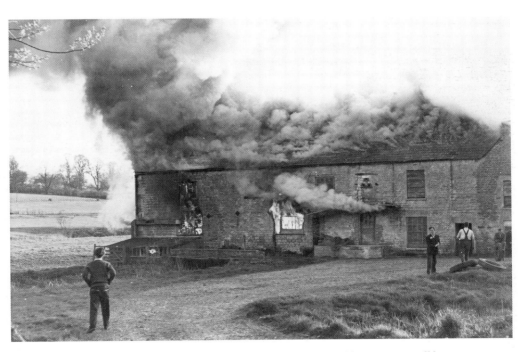

Moss's Mill was less fortunate and also was once a woollen mill and later a grist mill but was destroyed by fire, as the picture shows, in 1962. It lay just a little to the west of Curzon Park below Berhills Farm.

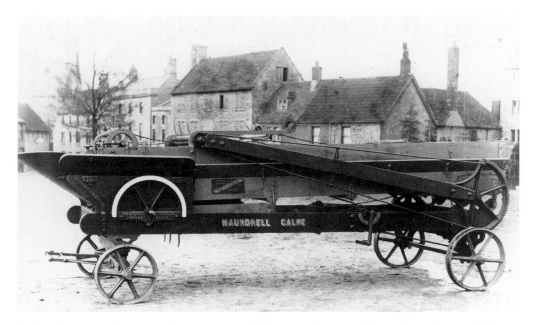

An iron foundry and engineering works was established in Horsebrook in perhaps the late 1850s. It was taken over by E.W. Maundrell when he moved from the Chapel in Back Road in 1885-86. Maundrell's was well-known for the agricultural machinery it produced, an example of which is this hay or straw elevator, posed for its portrait on The Green.

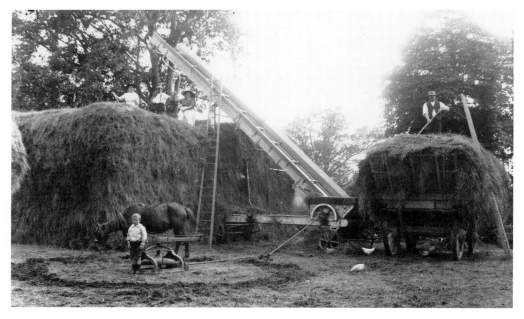

A Maundrell elevator at work lifting hay pitched from the wagon to the top of the ricks. As can be seen, the elevator was driven by shafts turned by the mechanism operated by the horse walking in a circle around it. Perhaps the small boy was in charge of the horse.

Calne Fire Brigade.

E. W. MAUNDRELL, Captain.

_____19

Dear Sir,

 I beg to inform you that I have arranged for the Brigade to practice on the Wharf at

Edward Maundrell had other interests. As this blank form of notification shows, he was the captain of the Calne Fire Brigade.

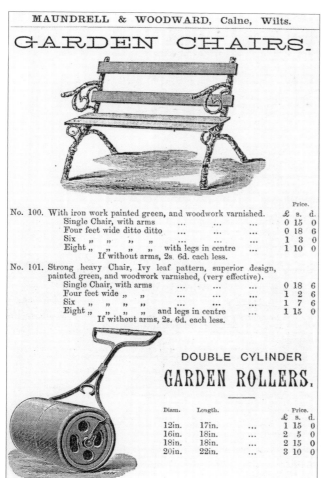

MAUNDRELL & WOODWARD, Calne, Wilts.

GARDEN CHAIRS.

		Price.
		£ s. d.
No. 100. With iron work painted green, and woodwork varnished.		
Single Chair, with arms		0 15 0
Four feet wide ditto ditto		0 18 6
Six „ „ „ „		1 3 0
Eight „ „ „ „ with legs in centre ...		1 10 0
If without arms, 2s. 6d. each less.		
No. 101. Strong heavy Chair, Ivy leaf pattern, superior design, painted green, and woodwork varnished, (very effective).		
Single Chair, with arms		0 18 6
Four feet wide „ „		1 2 6
Six „ „ „ „		1 7 6
Eight „ „ „ „ and legs in centre ...		1 15 0
If without arms, 2s. 6d. each less.		

DOUBLE CYLINDER
GARDEN ROLLERS.

Diam.	Length.		Price.
			£ s. d.
12in.	17in.	...	1 15 0
16in.	18in.	...	2 5 0
18in.	18in.	...	2 15 0
20in.	22in.	...	3 10 0

Maundrell's cast all kinds of ironwork as well as agricultural machinery and equipment for the Harris factories. This leaflet advertised their garden chairs and rollers. Examples of both of these came with our house when we bought it.

Dunn & Co. of No. 23 High Street were enterprising wireless and electrical engineers. They arranged a Great Radio Exhibition in the Corn Exchange, to be followed by a dance in the Town Hall using their amplifiers. Unfortunately the year does not appear on the advertisement. It was presumably in the 1920s.

At the upset price of £775.

CALNE, WILTS.

Particulars and Conditions of Sale

OF THE

Valuable Freehold Property

KNOWN AS

"The Calne Brick and Tile Works,"

COMPRISING

The Brickyard, with Kiln of modern erection, Pottery Shed,
Brickmaking Shed, and Engine House, Drying Sheds,
etc., etc., together with

Two capital Dwelling-Houses and Gardens,

As now being worked by the

Calne Brick, Tile, Pipe, and Pottery Works, Limited,

The whole having an area of

4a. - 0r. - 6p.

FERRIS & PUCKRIDGE,

IN CONJUNCTION WITH

HERBERT H. PARRY,

Have received instructions from the above Company to offer the foregoing valuable
property as a going concern, at

THE LANSDOWNE ARMS HOTEL, CALNE,

ON

WEDNESDAY. MAY 29th, 1907.

At 3 o'clock p.m.

Mr. ERNEST H. HENLY,
Solicitor,
Calne.

Messrs. FERRIS & PUCKRIDGE, Mr. HERBERT H. PARRY,
Surveyors and Auctioneers, Auctioneer,
MILTON, PEWSEY, WILTS, CALNE.
And 82, Queen Street, London, E.C.

Another lost industry was the brick and tile works at the top end of Oxford Road on the land now appropriately named 'The Kilns'. The works was put up for auction at the Lansdowne Arms on 29 May 1907, as this extract from the auction booklet shows. Presumably the 'upset price' of £775 was a low reserve. The further details within the book show that the down-draught brick kiln was lined with firebrick, had a 40ft chimney stack and could burn 16,000 bricks. The engine house, about 74ft by 30ft, had an 8hp horizontal engine by Griffin of Bath (presumably steam) with the pump and boiler by Maundrell of Calne. The outcome of the sale is not recorded, but it was probably unsuccessful as the brickworks closed in around 1907. Examples of bricks impressed 'CALNE' can be seen in the Heritage Centre.

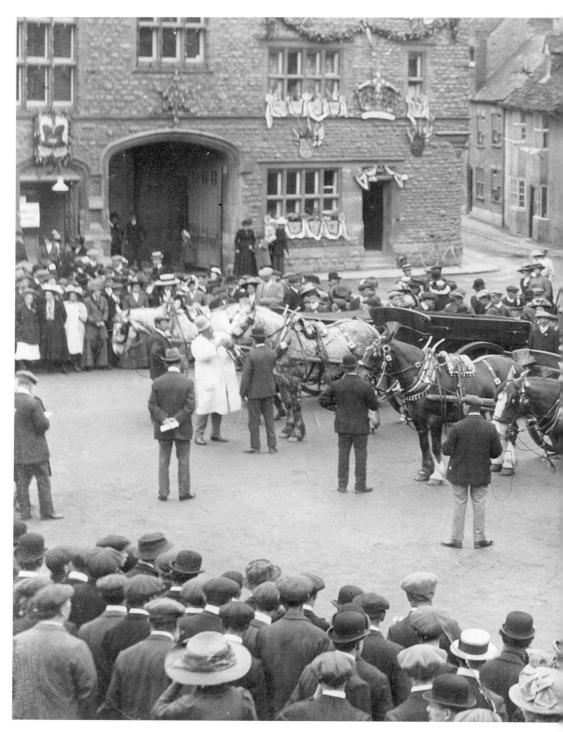

This competition for the best turned-out horse and cart took place on The Strand during the Coronation celebrations of 1911. The decorations on the Town Hall are visible in the background. The judge is wearing

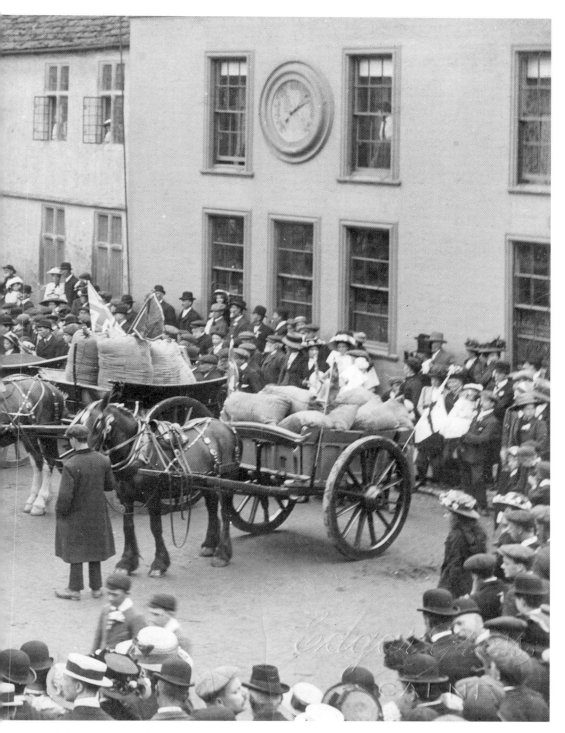

a light bowler hat and white overalls. It looks as if he is inspecting the muzzle of the grey horse, second from the left. The elaborate harnesses on the horses required for pulling even a small cart are apparent.

Freegrove Farm at Lyneham was owned by the Pocock family and was renowned for its prizewinning Jersey cattle. This postcard by J.J. Hunt shows one of them, named 'Grove Lady'. The date is not recorded but it must be before the First World War.

Calne also had its own cattle market. Previously held on The Stand, the market moved to purpose-built premises at Wenhill in 1929. Charles H. Parry & Son's sale note dated 19 July 1909 records a sale of a calf for £2 4s at 1s commission. The market closed in the late 1960s and the site is now built over as part of the Wenhill Heights Estate.

9

TRANSPORT

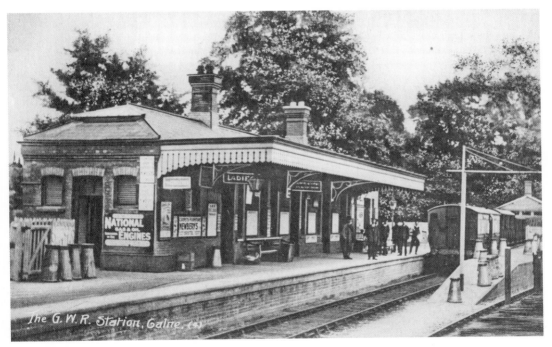

A postcard of Calne Railway Station in the early years of the twentieth century. The many milk churns standing on the platforms were a regular feature of rail transport at the time.

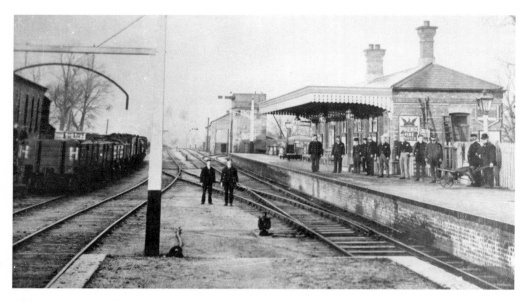

Calne Station, probably around 1900, with the workforce lined up on the platform to be photographed. The Calne branch running from Chippenham was opened in 1863 by a small local company, the Calne Railway. The line was built on the broad 7ft gauge but was narrowed to standard in 1874. The local company always struggled to make ends meet and was absorbed by the Great Western Railway in 1892. The buildings seen here had been built by the GWR in 1895 and they were later extended.

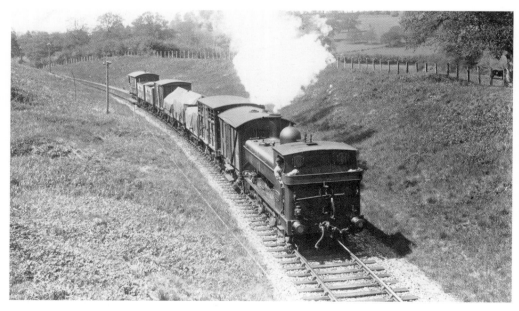

A typical freight train on the branch near Hazeland heading for Calne, probably in the early 1920s. The photograph is by the well-known railway photographer H. Gordon Tidey. The second vehicle was a cattle wagon, very possibly carrying pigs to Harris's.

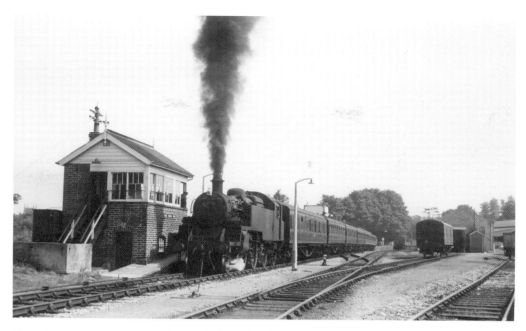

Towards the end of steam operation on the branch, Edward Spearey took this photograph of a tank engine built by British Railways waiting to leave with the Saturday through-train to Weston-super-Mare, which was an important feature of local life for many years. It left Calne at 1.07 p.m.

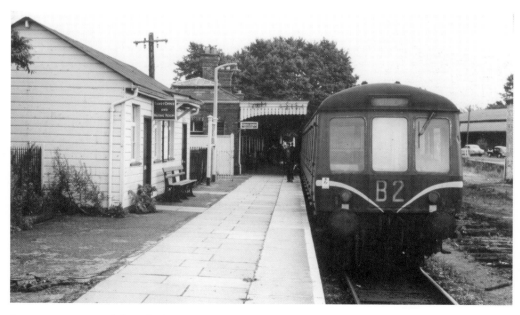

Steam operation ended on the branch around 1959 and passenger trains became operated by diesel railcars. This one is standing in the rather forlorn-looking Calne Station after the withdrawal of goods services in 1963. The rails in the goods yard have already been torn up. The branch closed with the ending of passenger services in September 1965.

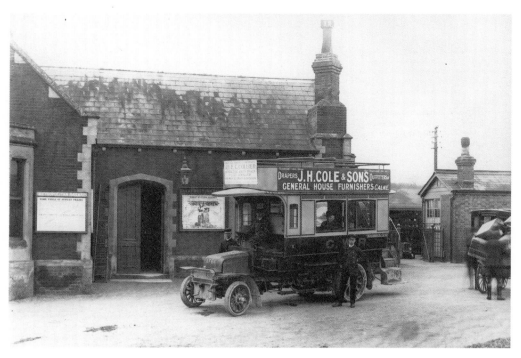

The GWR operated a bus service between its Calne and Marlborough stations from 1903 to 1913. The photograph shows one of its early buses outside Marlborough Station bearing the sign 'Marlborough and Calne' and giving major publicity to J.H. Cole & Son's shop in Calne.

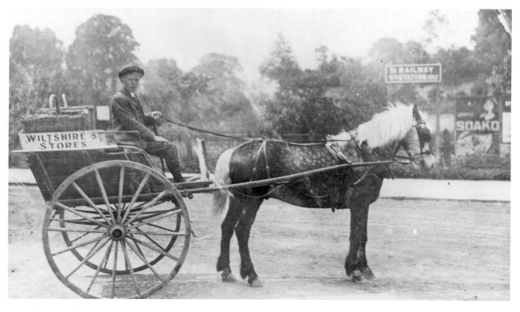

Standing at the junction of Station Road and New Road is this neat delivery cart and smart pony belonging to Wiltshire's Stores, with its young driver.

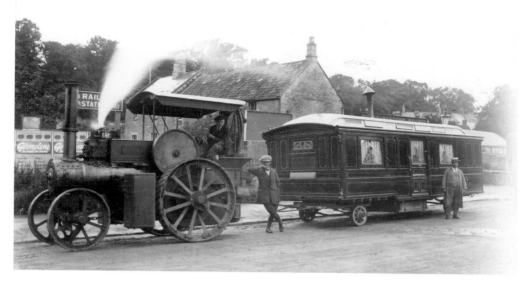

In the same location is this small steam traction engine or tractor belonging to Maundrell's, as evidenced by the plate on its side. The vehicle it is towing looks like a showman's caravan but nothing is recorded about it.

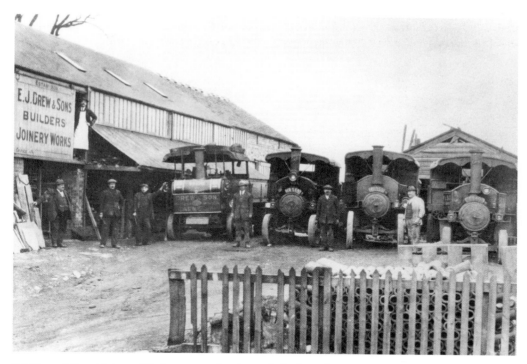

E.J. Drew & Sons' Joinery Works was on the site in Oxford Road opposite The Pippin, now occupied by a filling station. This photograph, probably from the 1920s, shows their splendid line-up of four steam lorries.

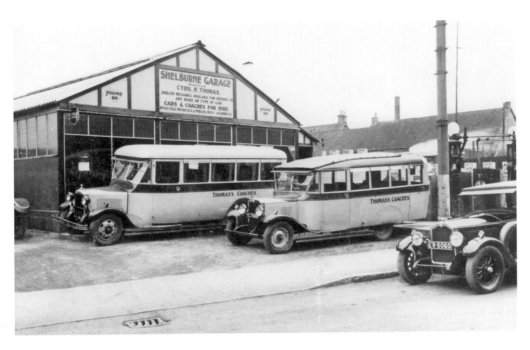

Two photographs of the Shelburne Garage of Cyril H. Thomas Ltd in London Road. The earlier view shows two of their charabancs in the 1930s and the later one the somewhat modified building some forty years later. An old-style filling station still exists on the left. Thomas Close now stands on the site of the garage.

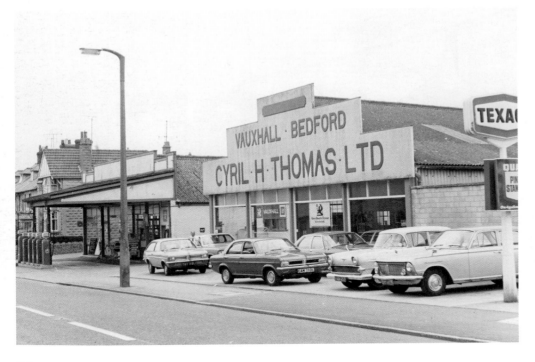

10

HARRIS'S

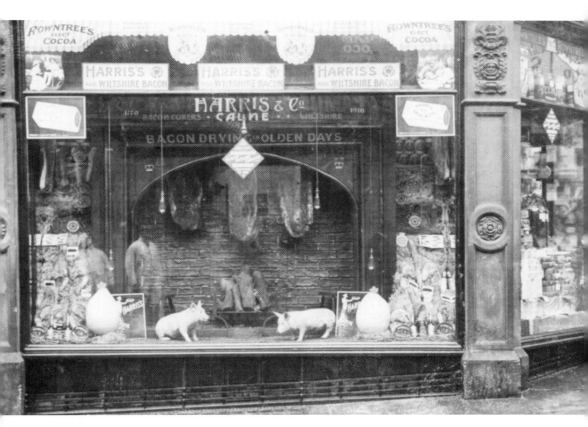

Harris's had a much appreciated retail shop in Church Street until the closure of the factory. The location of this earlier shop is not known. It has some interesting displays, including in the main window a presentation of 'Bacon Drying in Olden Days' with an open fireplace containing a side of bacon hanging above a fire.

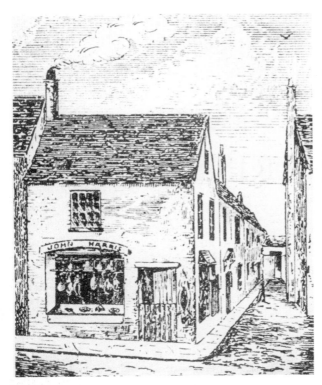

This engraving appears in a booklet called 'Careers with the House of Harris' published by the company in 1956. The engraving purports to represent the first shop established by John Harris in Calne in 1770, from which the later industry derived. The shop was in lower Church Street, perhaps at or near the junction with Mill Street. It is not clear whether the engraving is speculative or derived from a contemporary drawing. The Heritage Centre holds such a drawing, unfortunately undated, which curiously does not include the building on the right. The original Harris business was a small-scale butchers shop and it was not until the mid-nineteenth century that bacon curing became a major industry.

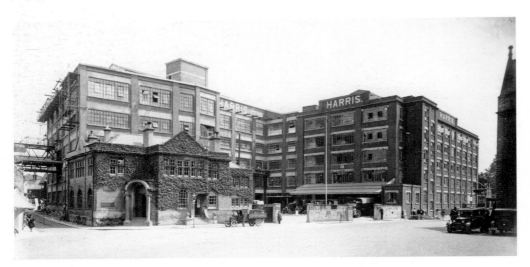

For many years two branches of the family ran separate bacon factories north and south of Church Street, but they amalgamated as C. & T. Harris (Calne) Ltd in 1888. The new company expanded its activities, particularly on the south side of Church Street. This photograph is dated almost illegibly, but it may be 27 June 1932. That fits in with the state of the buildings. The right-hand section (originally known as St Dunstan's after the house on the site) was built in 1920. The left-hand section was built in around 1932 and as there is still scaffolding on the wall flanking Church Street, it was probably nearing completion when the photograph was taken.

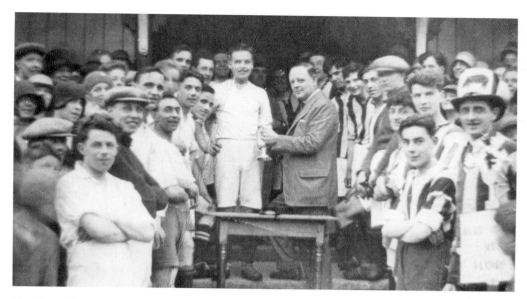

The Harris business did its best to provide social and sporting facilities for its workforce. The managing director John Bodinnar was particularly keen on this and is seen here presenting a cup to the Harris Football Club winners in the late 1930s.

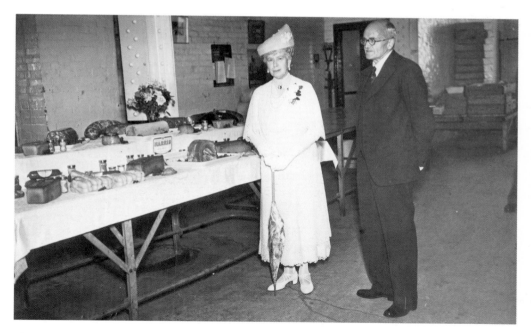

The Harris factories were heavily engaged in food production for the war effort between 1939 and 1945. In 1941 Queen Mary, widow of King George V, paid a visit of appreciation to the factory. She is seen here with Mr Percy Redman, local director, alongside a display of the factory's products. Meanwhile the managing director, John Bodinnar, had been seconded to the Ministry of Food and was subsequently knighted for his services.

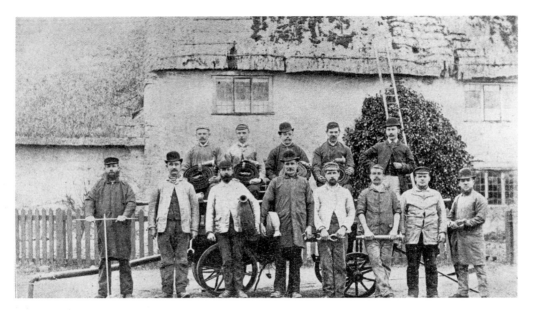

This surprising photograph is recorded as showing the Harris Fire Brigade and engine in the early 1890s. No doubt the sprawling factories with their smoking ovens needed the safeguard of a fire brigade while provision by the municipality was very meagre; it was just another hand-worked pump like the one in the picture. I cannot locate the cottage in the background.

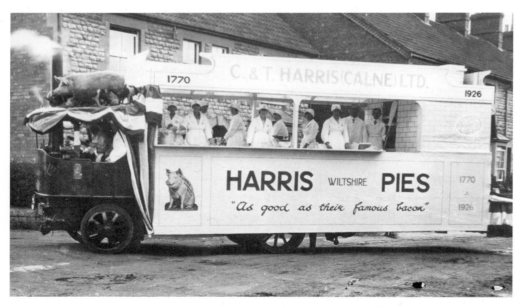

The Harris workforce participated strongly in local activities like the carnival. This steam lorry with a temporary display body bears the date 1926, so presumably it was prepared for the Shopping Week of that year. The ladies in the shop threw their goodies into the crowd. Note the model pigs clustered around the chimney on the cab roof and the sitting pig picture on the side of the lorry, which was a well-used symbol of the business. This picture was probably taken in The Pippin.

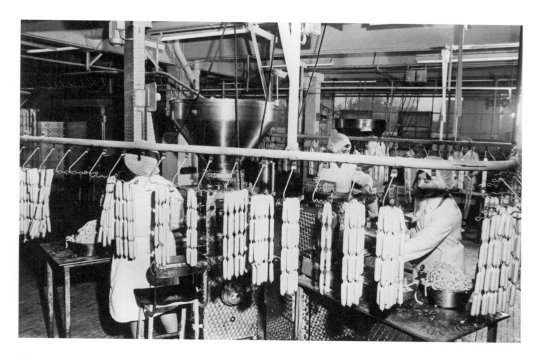

Two pictures of work in the factory at an unknown date, perhaps in the 1930s after the erection of the modern factories. The top picture shows strings of sausages on a conveyor system and the bottom picture has sides of bacon in the background, while in the machine in the foreground a side of bacon is being injected with salt, an early part of the curing process.

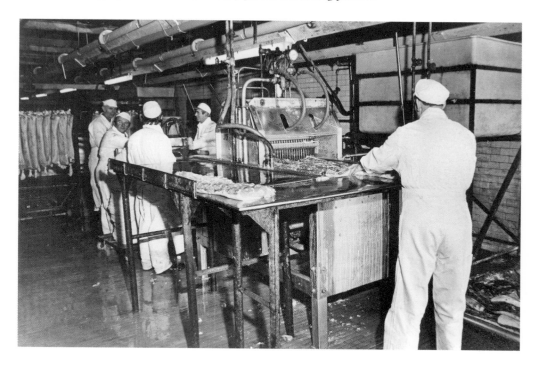

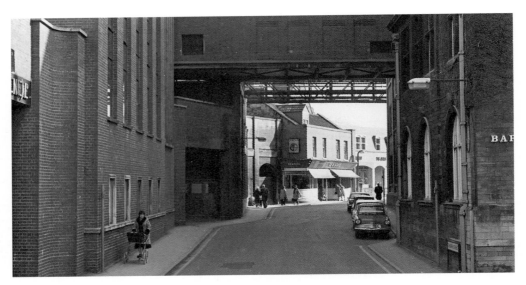

The Harris factories dominated the town in many ways, not least in Church Street where the modest shops on the northern side had long since been swept away to be replaced by a boiler house and factory entrances. Of the old shops only Dixon's in the centre survived. The bridges over the street, giving it a very industrial air, linked the factories on each side of the street. The building on the left with tall windows was the boiler house, built in 1955 to house a large coal-fired boiler.

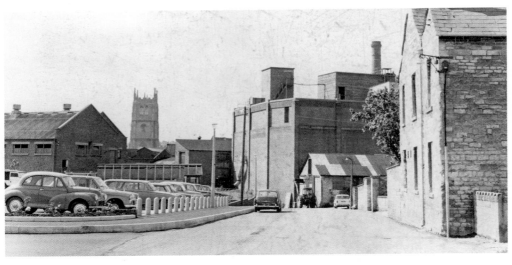

The southern end of The Pippin was also dominated by the factories. On the left, and north of the road, was the lairage built in 1938. Pigs were delivered here, as evidenced by the large lorry, and were held for twenty-four hours before slaughter. Further lairage and the slaughterhouse were reached by a bridge across The Pippin to the building left of centre. The windowless building in the centre contained processing rooms and was built in 1937. This photograph must have been taken soon before the demolition of the factories but after the one-time allotments on the left had been converted into a car park. The tin-roofed building in front of the 1937 block was the slaughterhouse of Messrs L. & O. Hawkins, whose premises stretched to their shop in the High Street.

11

MODERN TIMES

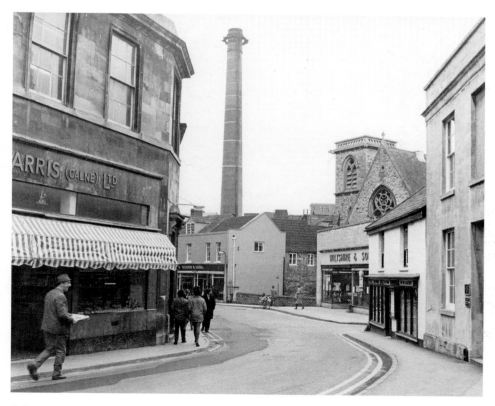

Calne in transition. A view in Church Street after Wiltshire's original store had been replaced by their first supermarket. Harris's retail shop is on the left and one of the Harris boiler chimneys in the centre is about to be demolished. It had been built in 1918 and was demolished before the remainder of the factory. In front of it is Dixon's store and to the right the Free Church. The picture probably dates from the early 1970s.

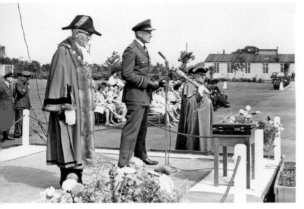

The Royal Air Force Camps at Yatesbury and Compton Bassett, established during the Second World War, were an important feature of Calne life for many years. Used principally for radio training they had quite a rapid turnover of personnel, most of whom reached the camps along the branch railway line. They would also come into the town for recreation when they could. The camps closed down in the early 1960s and almost all traces of them have since been obliterated. The picture shows the closing down parade for RAF Compton Bassett in 1964. Air Vice-Marshal J.K. Rotherham is speaking, with Mayor Harold Weston on his right.

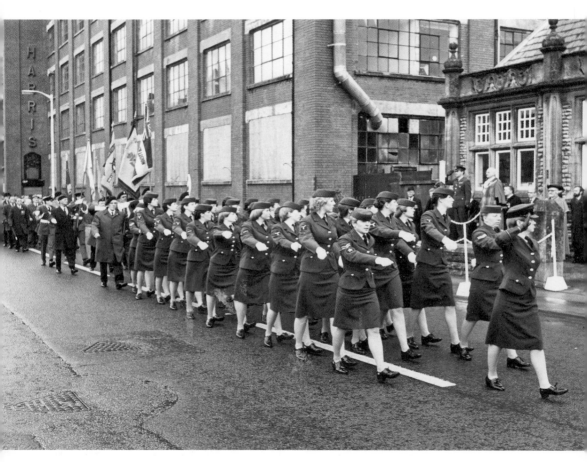

Another military parade. This time it is the Remembrance Parade of 14 November 1982. A contingent from RAF Lyneham is shown marching past the saluting base outside the old library where the Mayor, Edward Cooper, stands to attention. The British Legion contingent follows on. In the background the boarded-up windows of the 1920 Harris factory indicate that closure has taken place and demolition is near.

A view of Wood Street when there were fewer parking restrictions and the cars were different. The buildings remain much the same, although Giddings' Wines is now an Asian restaurant and the Spar grocery shop is an insurance brokers. The uncovered roof in the background marks the last days of a building known as 'The Candle House', which may once have been a building where candles were manufactured, a trade which flourished in Calne in the days before gas and electric lighting.

After the widening of the High Street and the West Hill diversion, the top end of the High Street was pedestrianised. It caused considerable surprise when the telephone boxes previously outside the Post Office were moved into this position at the point where the High Street was cut in two. The move was strongly opposed by the Civic Society as the position seemed incongruous, the boxes spoiling the vista down the High Street to the Town Hall. Paul Buckeridge, founder member and long time secretary of the Civic Society, smiles as he points to the post boxes on Christmas Eve, 1975. At that time his family's business still operated from the building behind his shoulder, while the Harris factory still towered above New Road at the left. Ironically, the telephone boxes, little used since the spread of the mobile phone, have been listed as of historic or architectural importance.

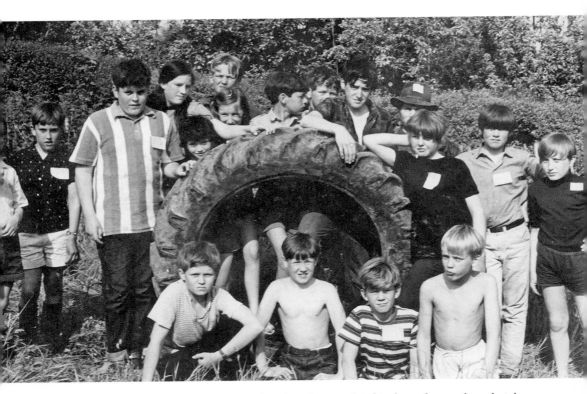

Another Civic Society activity. Clearing the River Marden of accumulated junk was frequently undertaken and remarkable things were found, including this huge heavy-duty tyre. The children had pulled it out of the river, probably in the area of Doctor's Pond, with what became the Somerfield car park behind them. Some readers should be able to recognise their younger selves. Incidentially, although Doctor's Pond is commemorated as the place where Dr Priestley carried out his experiments to isolate oxygen, he probably did this elsewhere, perhaps in a pond in the garden of the adjoining house where he lived.

In its last years the Calne Borough Council was much occupied with the project to build a sports centre and swimming pool on a site near what was then Bentley Grammar School. Eventually a joint scheme was undertaken with the County Council, but by the time the pool was opened in 1976 the North Wiltshire District Council had superseded the Borough. The picture shows the pool in its early days. In recent years the complex has run into financial difficulty but has been rescued by a locally based friendly society which continues to promote it for the benefit of the community.

A glimpse of Curzon Street, probably on the same date as the previous picture of Wood Street as the vehicles look similar. In the background the shell of Phelps Parade is forming with the gable of the Zion Chapel visible beyond. The buildings to the left and right of the street remain today except the house at the end of the row on the right. The date is probably about 1972.

A further stage in the development of Phelps Parade, with the shells of the buildings now complete.

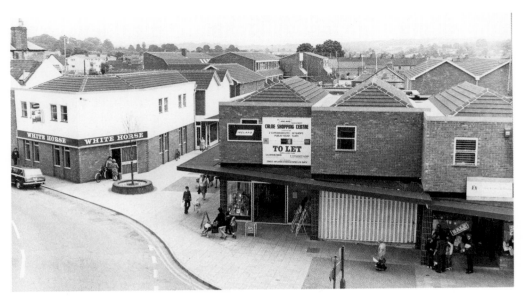

Phelps Parade as completed in 1973. Some shops are already open and so is the White Horse pub which replaced the old building of the same name on the same site. It has since ceased to be a pub. In the centre can be seen the flats above the shopping centre. The far block has recently been demolished to make way for new shops and flats. Unfortunately, those shops still await tenants. In front of the White Horse a birch tree was planted in the circular raised area. Sadly it did not survive long but happily it was replaced by the popular pig sculpture by Richard Cowdy, provided by the Calne Civic Society.

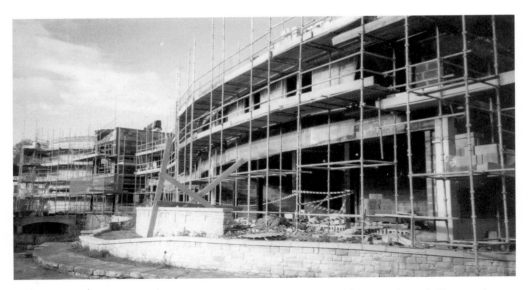

The most recent of the major developments in Calne was the new library and Beach Terrace along the Marden facing Church Street. The Marden at this point had been hemmed in by the Harris factories and ran in a straight line between concrete banks. Massive and very expensive works were undertaken to divert the River Marden to make room for the terrace, alleviate the danger of flooding and provide an attractive area of riverside landscaping.

Left: On 7 December 2001, Her Majesty Queen Elizabeth II became the first reigning monarch to visit Calne since King Edward VII in 1907. The Queen's visit was much longer and more comprehensive than the King's fleeting call. The Queen began by inspecting an exhibition of Calne activities set up in the Town Hall. She then crossed The Strand where she can be seen greeting townspeople lining the road. She is accompanied by the Mayor, Liz Watkins, behind whose shoulder can be glimpsed the Town Clerk, Ann Kingdom.

Below: Across The Strand, Her Majesty unveiled a plaque to commemorate the newly installed head sculpture (it is said she looked a little bemused by it) and then entered the new library, which she declared officially open. The photo shows her talking to local people when she emerged. The Lord Lieutenant of Wiltshire, Sir Maurice Johnson, looks on. The Queen then went on to conclude her visit by joining the Duke of Edinburgh at the John Bentley School.

Other titles published by The History Press

Chippenham
MIKE STONE

This collection of old photographs and postcards provides the reader with a fascinating and informative guide to Chippenham and its history over the past hundred years. The book spans the expansion and development of the thriving market town by the River Avon from the nineteenth century to the present day. This tribute to Chippenham is sure to interest the casual visitor and to reawaken memories of long ago for local residents.

978 0 7524 5383 5

Wiltshire Murders
NICOLA SLY

Wiltshire Murders brings together numerous murderous tales, some which were little known outside the county, and others which made national headlines. Nicola Sly's carefully researched, well-illustrated and enthralling text will appeal to anyone interested in the shady side of Wiltshire's history, and should give much food for thought.

978 0 7524 4896 1

Marlborough Revisited
MICHAEL GRAY

This fascinating collection of over 200 photographs traces some of the many ways in which Marlborough has changed and developed over the last 150 years, and the ways it has remained untouched. This book will appeal to anyone with an interest in the history of the area, and awaken fond memories of a bygone time for those who worked or lived in this beautiful Wiltshire town.

978 0 7524 3986 0

Wiltshire Railways
KEVIN ROBERTSON

Following the expansion of the Great Western, Midland and South Western Junction and the London and South Western railway companies, *Wiltshire Railways* begins with photographs of the South Western line commencing from Salisbury. We then proceed around some of the LSWR routes, along the main GWR line and finally visit the numerous branches radiating throughout the county. Kevin Robertson is a respected railway historian who has written numerous books on Britain's rail heritage.

978 0 7524 5465 8

Visit our website and discover thousands of other History Press books.

www.thehistorypress.co.uk